To Mum
A very
Happy Birthday
hopefully one
day I can
show you round
here Lots of love
Becks
xx.

ROYAL
BOTANIC GARDENS
MELBOURNE

Photographs by Greg Elms
Text by Deborah Morris

A SUE HINES BOOK
ALLEN & UNWIN

A Sue Hines Book
Allen & Unwin
83 Alexander Street
Crows Nest NSW 2065
Australia
Phone: (61 2) 8425 0100
Fax: (61 2) 9906 2218
Email: info@allenandunwin.com
Web: www.allenandunwin.com

National Library of Australia
Cataloguing-in-Publication entry:

Morris, Deborah, 1956–
The Royal Botanic Gardens Melbourne.

Includes index.
ISBN 1 86508 551 0.
ISBN 1 86508 663 0.

1. Royal Botanic Gardens (Melbourne, Vic.). 2. Botanical gardens - Victoria - Melbourne. 3. Royal Botanic Gardens (Melbourne, Vic.) - History. I. Elms, Greg. II. Title.

580.739451

Designed by Elizabeth Farlie Design
Typeset by Pauline Haas
Printed in China by Everbest

10 9 8 7 6 5 4 3 2 1

CONTENTS

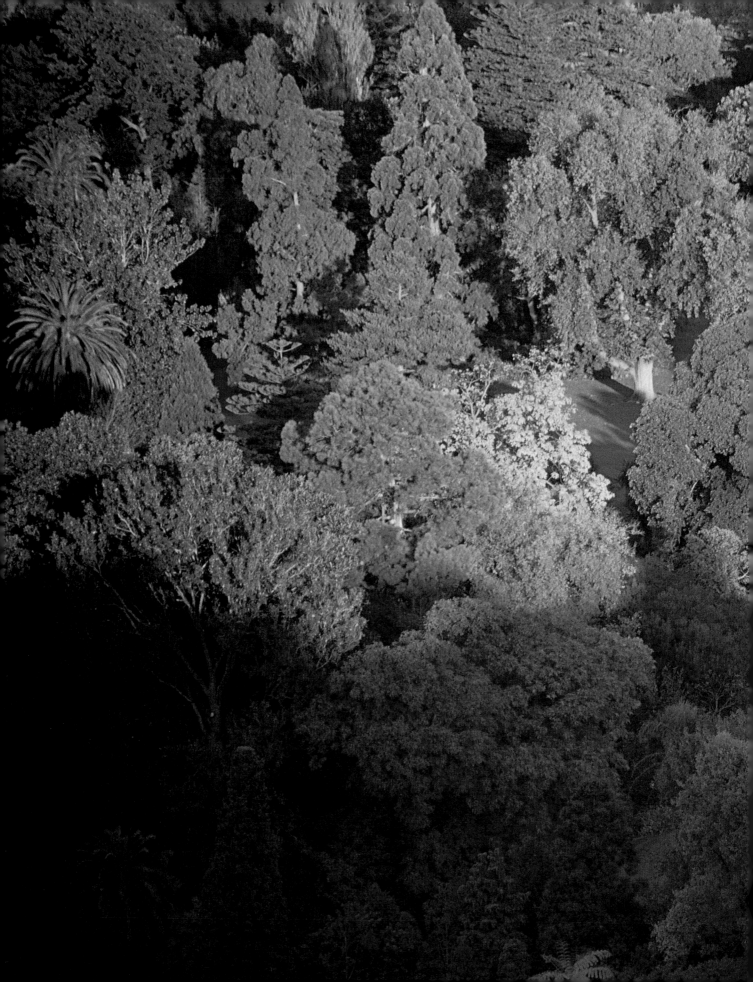

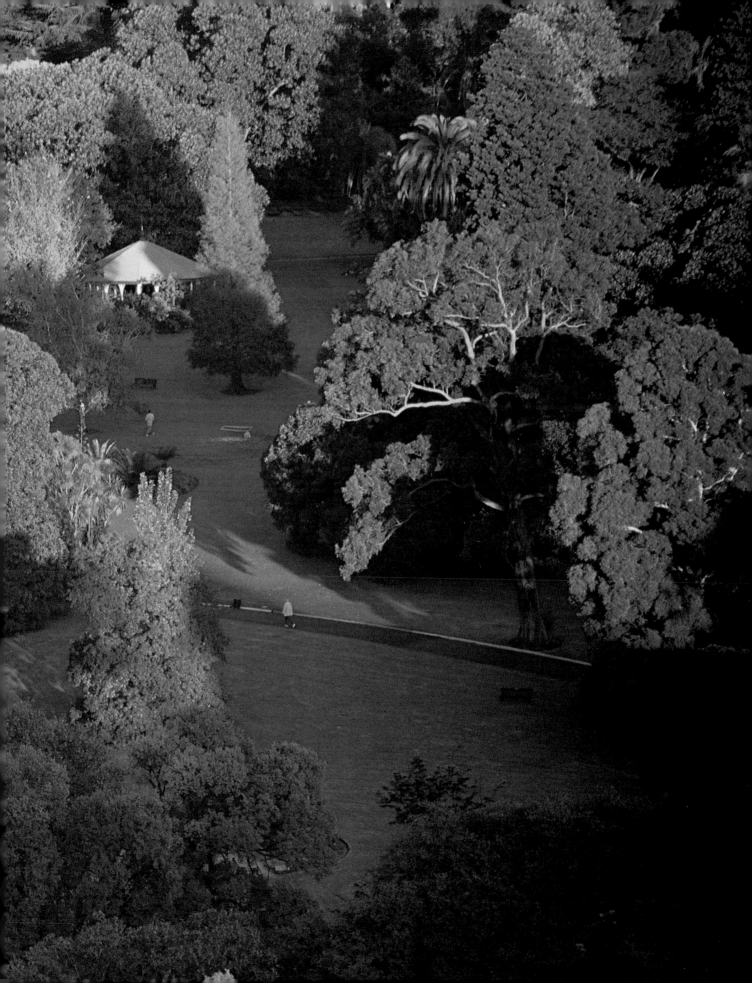

FOREWORD

A botanic garden is much more than a park with an assortment of plants grouped together to stimulate the eye. It is much more than a public garden. It combines many features that teach us more about the crucial role plants play in our world today.

The lush, verdant landscapes of the Royal Botanic Gardens Melbourne offer the visitor a visually stimulating blend of both exotic and indigenous flora in a world-renowned setting. However, to fully understand the role of a botanic garden, one needs to look beyond the aesthetics.

The Garden's Herbarium staff further the pursuit of botanical science, with both the living and preserved collections of the Gardens. Conservation and research are rapidly expanding as plant species in both urban and rural parts of Australia face major threats to their habitat and ultimate survival. The Gardens is also a wonderful backdrop for 'nature's classroom', providing a diverse range of education services to nearly 40 000 primary and secondary school children each year. Finally, the Gardens is a magnificent location for recreation and pleasure. Whether it be a family picnic on a lawn, Devonshire Tea by the Ornamental Lake, cinema under the stars, lunch at Observatory Cafe, Shakespeare on a balmy summer's evening, a wedding ceremony or just a leisurely stroll, the Gardens is able to offer all this and more in a site of unsurpassed and rare beauty.

I invite you to read on and learn more about the fascinating history of the Royal Botanic Gardens Melbourne, from when the Bunurong and Woiworung people traversed the land to the present day, with the new challenges of the 21st century. This book presents a range of beautiful images and engaging insights into circumstances that have shaped the Gardens. It might also give you the opportunity to take a little time out from the rather frantic pace of today's life, to absorb some of the nuances of the story of the 'Jewel in Melbourne's Crown'.

I trust you will enjoy this book and we at the Royal Botanic Gardens look forward to your next visit.

Dr Philip Moors
Director
Royal Botanic Gardens Melbourne

Previous page: The Gardens from Government House, late afternoon.

THE
DREAMTIME

BEFORE THERE WERE GARDENS, there was scrub and bush and billabongs and a river. Colours of green and brown, with so many shadings in between, appeared almost washed out by summer's strong sunlight or the cold wind in winter. Yet the landscape contained the ability to surprise, particularly in spring, when the trees and shrubs and grasses blossomed into vermilion, yellow, white and purple.

Let's pretend we're airborne, looking down, on the wings of a black raven. Waa, the people who live here call him. Waa, the keeper of knowledge and a protector of communities.

It's a cloudless late summer's day. We swoop down, moving inland from the wide and free-flowing river teeming with freshwater fish, eels, mussels and waterfowl. Past riverbanks of tall gum trees, painted a faded white or sage or grey. Past tall Red River Gums, whispering She-oaks, wattles and dogwoods, the black bird's wings take us south of the river, into a large area of open grassland.

Around here, the soil varies from swampy silt to earth that has been built up from sandstone and wind-blown sand from the sea. Once, long ago, the soil and its vegetation were darker, richer – a rainforest reaching to the riverbanks. But 50 000 years of climatic changes and people's rearrangement of nature – the burning-off, the uprooting of tuberous plants, the killing of animals and birds – have changed its appearance. Burning off the scrub has caused the topsoil to blow away, to be replaced by different sand varieties.

Black wings now focus and turn, eventually circumnavigating an area that will one day become a botanic garden. It's peaceful here, with its undulating hills and lagoons and billabongs. Banksia and eucalypt trees spread over the flats, and the slopes are covered in native grasses: soft, green Kangaroo Grass – the Koories call it 'weeping grass', as the slender stem tends to bend over from the weight of its flower head – and common Tussock Grass. The grasses bend with the wind; for a while, it is like a sea of green, until we fly in closer.

Now the area is covered with Swamp Tea-tree and decorated with scrub vine's spiky white flowers. The terrain rises and falls in a series of terraces that overlook a lagoon fed by a small stream. Around the lagoon are clumps of spiky

Tall Sword-sedge and ornamental Native Bulrush. These plants provide a sheltered haven for the birdlife, which fills the land with sound.

The crow's call and the kookaburra's laugh join the cacophony from brightly coloured parrots, cockatoos, lorikeets and bellbirds. A gentle breeze parts the rushes like a comb and we see emus and wallabies searching for food. Swans dip their necks into the lagoon, eels slither about in the dark water and, in the trees, possums and koalas hide.

Across the lagoon, we catch a glimpse of two kangaroos, the male standing alert, his ears twitching; the female with her head bent, searching for food. A spear flies through the air and impales the male; the suddenness of the movement causes Waa to quickly fly upwards to the safety of a high branch.

Two tall, lithe, dark men run towards the fallen marsupial. They are part of a clan known as the Wurundjeri baluk ('white gum tree people') and they are passing through this area to what will one day be known as the Dandenong Ranges. They will spend the winter up at the Ranges, where more food and shelter is to be found than down by the swollen river and its tributaries.

Many people move through these lands and they are ruled by a complex set of laws and beliefs, all of which inevitably stem from a spiritual connection with nature. The land is their bible and they walk it every day. They see moral lessons in how nature lives and try to live by them.

Groups of extended family members form traditional communities. There are four major communities living in and around Melbourne, who see themselves as a nation of men and call themselves Kulin, the Koorie word for man. The territory of three of these communities borders the great bay we know now as Port Phillip. These are the Woiworung, who live in the area drained by the Yarra River and its tributaries; the Bunurong, who claim the land to the south; and the Wathaurung, who live in the east. The fourth clan in the Kulin confederacy, the Taungurong, hunts and roams in the north.

The people of this land have identified it as their own since the time of the Dreaming or Creation. Bunjil – the Creator – is personified by the wedge-tailed eagle and it is he who made the earth and formed its creeks and rivers by

"After Bunjil had sung into existence the great river, the billabongs, the wetlands, the birds, animals, fish and plants, all of this part of the world carried in it a piece of the Koories' soul."

cutting the earth with the large knife he always carried. After Bunjil had sung into existence the great river, the billabongs, the wetlands, the birds, animals, fish and plants, all of this part of the world carried in it a piece of the Koories' soul. They too sing the story of the Creation, as they believe it recreates the landscape every time, as a heartbeat keeps us alive.

The Wurundjeri baluk belong to the Woiwurung clan, along with five other groups. Although these groups of extended families operate as separate units in a well-defined area, they are not hostile and, because they share similar languages, will join with other clans to share food, exchange wives or perform ceremonial duties such as corroborees. They perform corroborees regularly and for a number of reasons – to welcome visitors from other communities for an

Overleaf: Last light on Nymphaea Lily Lake.

Overleaf, right: The Gardens is home to a host of birdlife such as the cormorants, coots and swans pictured here.

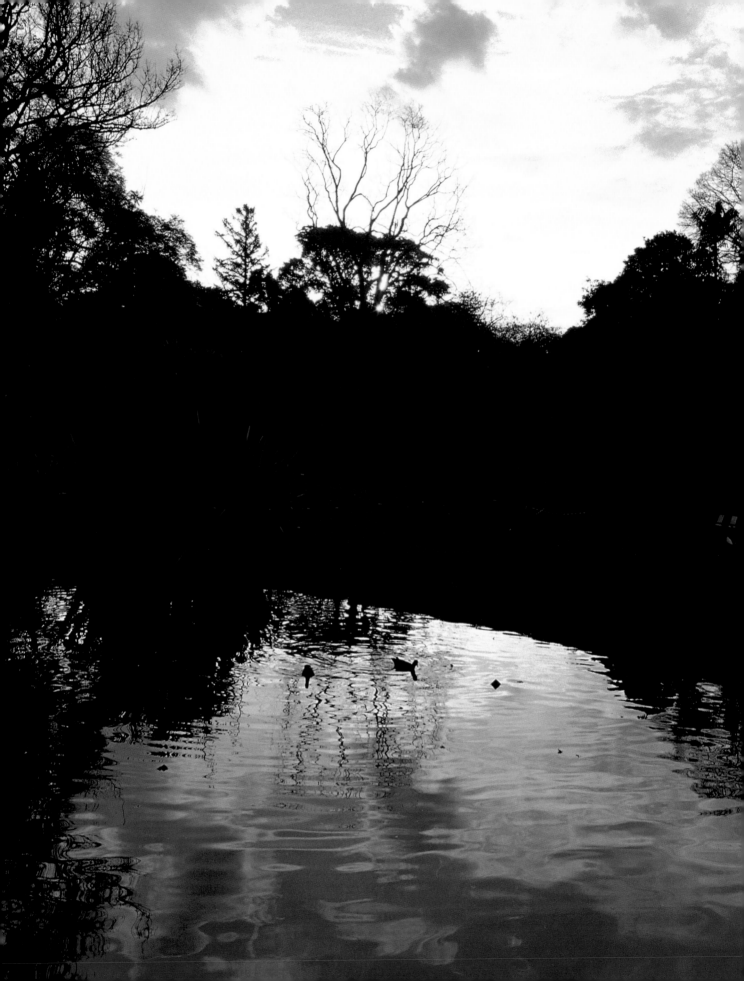

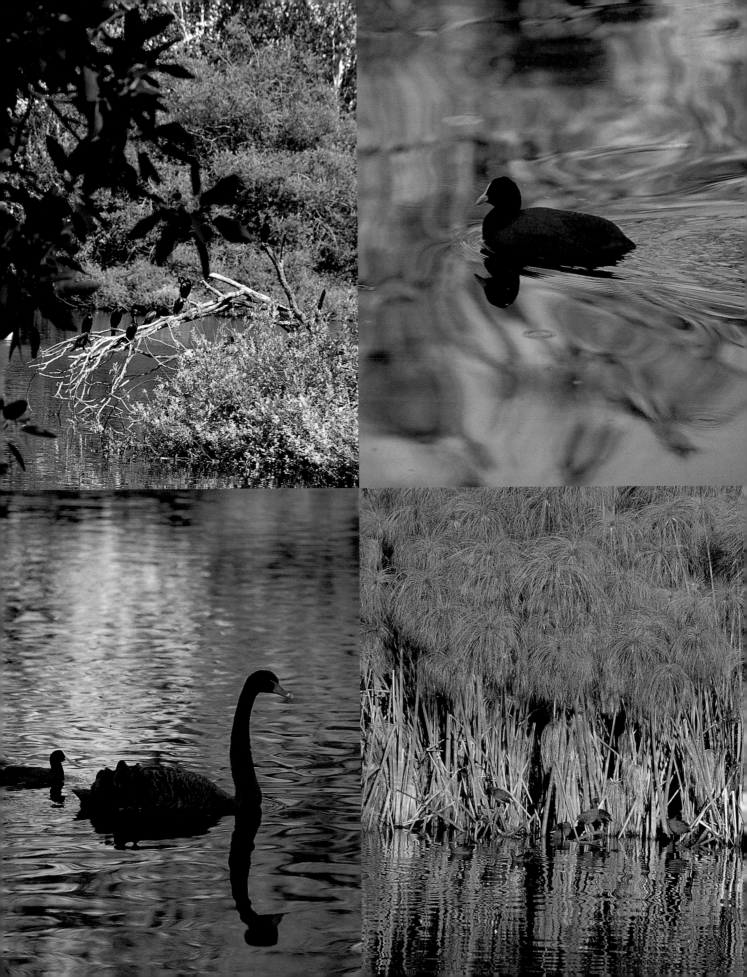

initiation ceremony or to tell a story, through dance and song, about their myths and legends.

It is difficult to know how many people lived and moved through these lands – some have estimated between 7000 and 10 000 – but we do know that they have been here for more than 50 000 years. They have lived through many climatic changes, from the Ice Age onwards. From the beginning, they were nomads who hunted and gathered.

But let us return to our two hunters, about to take apart a kangaroo for meals now and later. These men might belong to a camp made up of several families, or to a single-family camp. They may have come from the coastline around what is now known as Mornington Peninsula, on their way to the mountains we now call the Dandenong Ranges, and have stopped here for two or three days because of the proximity to fresh water.

While the men hunt the larger game, the women and children are busy, perhaps fishing for eels or collecting plant foods, such as the Yam Daisy, or murnong, which grows along the banks of the nearby stream. The Yam Daisy has yellow petals and looks like a dandelion. Sometimes entire fields are filled with its bright blooms. Their tuberous roots are considered delicious and are eaten either raw or after being roasted over a fire.

Around the swamps and marshes, the young shoots and roots of bulrushes are collected and eaten. The fruit and seeds of white mangrove and kangaroo apple and the roots of water ribbons are also gathered for food, while some rushes are made into baskets and decorative necklaces.

Once the search for food is completed, the women and children turn to collecting other roots and leaves for medicinal use, such as the River Mint, with its small, pale-mauve flowers, which is mixed with hot water to produce an inhalation for colds and coughs.

The trees themselves are important to the Koories, both spiritually and for providing sustenance, shelter and canoes. The River Red Gum often marks corroboree places; large pieces of bark are used to make canoes; and hollowed-out galls (abnormal tissue growths caused by insects) provide food

"The River Red Gum often marks corroboree places, large pieces of bark are used to make canoes, and hollowed-out galls provide food containers. Its gum is used to treat burns, and its tannin is a cure for diarrhoea."

containers. The River Red Gum's flowers provide nectar and attract bees, making it a good honey tree. Its gum contains antiseptic properties and is used to treat burns; while its tannin is considered a cure for diarrhoea. The gum collected from wattles is considered a great delicacy and is eaten either raw or dissolved in water. Gum is also obtained from an insect similar to the cicada, which lives in manna gums, and, like the larvae of some ants and honey, is prized as a source of sugar.

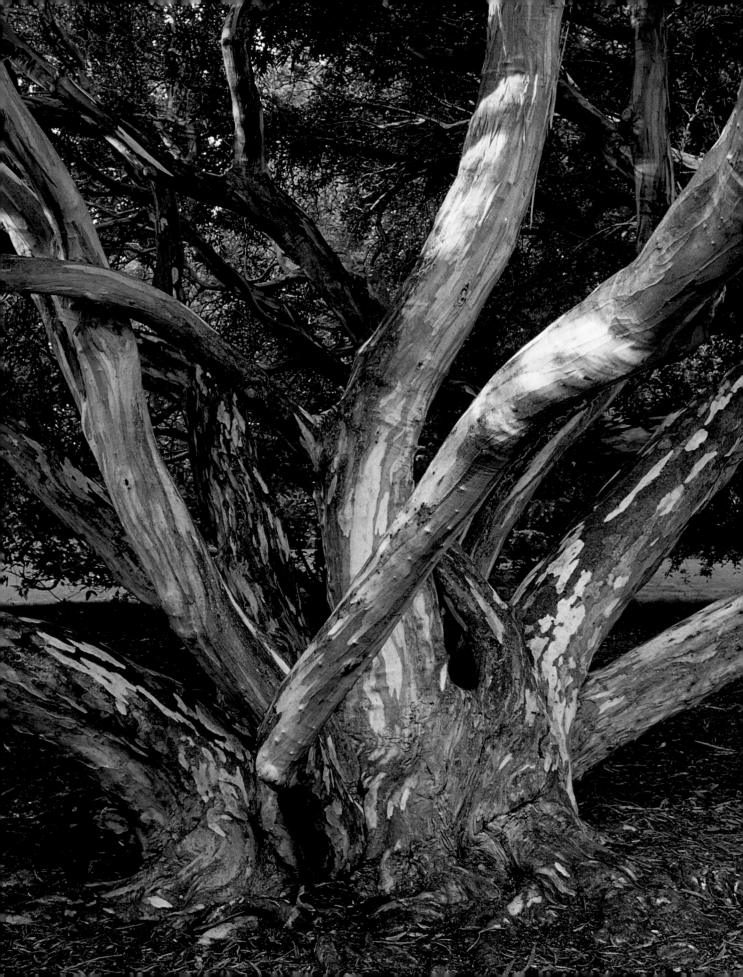

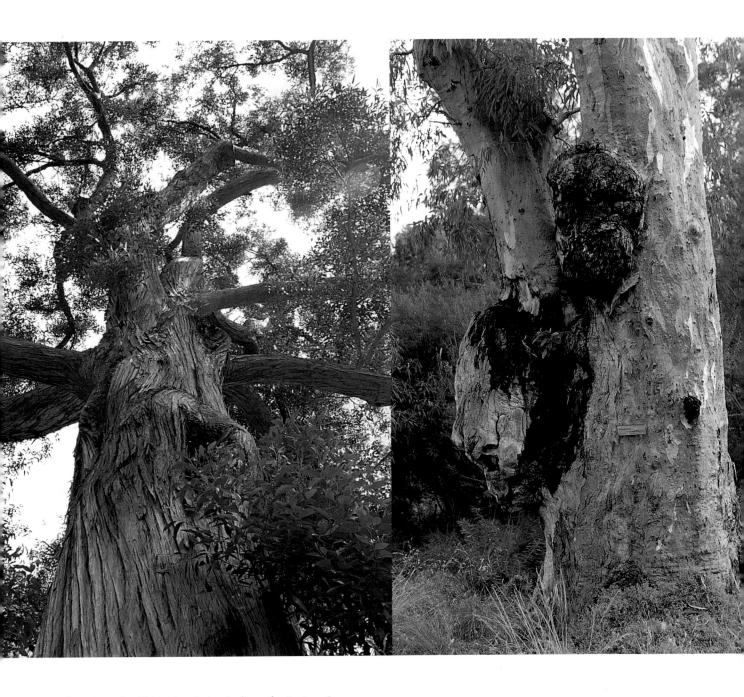

Left: A Kanooka (Tristaniopsis laurina) *on the Eastern Lawn.*

Above left: A Yellow Stringybark (Eucalyptus muelleriana) *on the Eastern Lawn.*

Above right: The Lion's Head Tree (Eucalyptus camaldulenisis) *is named for its odd protrusion shown on the left. Galls such as these were hollowed out and used as food containers by the aboriginal inhabitants of this area. The tree stands on the Indigenous Promontory, an area conserving indigenous vegetation that has survived since before the establishment of the Gardens.*

Finally, water is fetched from the stream and taken back to the campsite in wooden bowls or buckets made from the gnarled section of a tree trunk.

At dinner time, everyone returns to the campsite. A fire pit is dug and stones put in the embers, and the women start preparing the meal. While the food is cooking, the men might repair their hunting tools or an animal hide, or carve a wooden bowl. Or they might skin possums for cloaks. On average, eighteen skins are needed to make one cloak and the construction is a long, slow process. The animal needs to be carefully skinned, and the pelt cut into squares and stretched on bark sheets, with wooden pegs to hold it taut. Then the inner side is scraped clean with a mussel shell. When dry, incisions are made on one side of the skin to make it more flexible. It is then painted with red ochre and charcoal mixed with fat to make the cloak waterproof. Eventually, each piece is carefully sewn together with sinew or muscle fibre from kangaroos, the holes being punched with kangaroo teeth.

The children will play until called for dinner. The boys play at games that improve their throwing skills or with a ball constructed with yarn made from possum fur. They kick the ball into the air, then attempt to beat the other players to catch it. The player who marks the ball then kicks it into the air again, and the game continues. The girls play games by weaving string through their fingers, or watch their mothers grind flour from the seeds of a white mangrove plant.

Perhaps tonight it will be colder than usual, so the men build shelters made of sheets of bark two metres long. These bark slabs overlap and are quite waterproof.

The clan will probably spend about two or three days here before moving on. They travel light, leaving behind heavier objects such as wooden buckets or tools that are of particular use only in this part of the land, such as grinding stones, mortars and pestles. These items are put in convenient hiding places and there they will stay until the return journey.

★

Traditional Koorie life such as this would end with the arrival of the white man in 1835. Sealers and whalers operating around the coast and in Bass Strait from the end of the eighteenth century had already left their mark, through the introduction of some diseases. But nothing could have prepared the Kulin for the invasion of the Europeans.

From the moment John Batman arrived with his contract to buy land from the Koories, they were at a disadvantage. The indigenous people believed they were allowing the colonists free access to the land; they would never have sold the land as they did not believe they owned it in the first place. But, once that contract had been signed, they were virtually barred from the area. Cattle and sheep grazed on soil that provided much of their food and they were forced to trade their waterproof possum skin cloaks for food. This alone caused many to die from pneumonia.

Although the Kulin nation was generally not aggressive and the colonists were generally not intolerant, the latter did not understand the former. It was believed that the Aborigines were as devoid of belief and morality as they were of land rights, and understood that the best way to 'deal' with them was to 'civilise' them. So they were herded into Protectorates, children were separated from parents. The animals they hunted were destroyed, as was the source of their fresh drinking water.

When the Aborigines retaliated, they were shot, or poisoned with tainted flour. They contracted European diseases such as syphilis and smallpox. And, the saddest part of all, they themselves realised the end was near and so practised birth control and effectively stopped having babies. Fewer than 30 years after settlement, the numbers of Woiworung and Bunurong people were reduced to only 28.

But, in the land where the Royal Botanic Gardens Melbourne now blooms, the spirit of the Kulin is ever-present and is the source of the Gardens' beauty and serenity. Like the indigenous cultures, the indigenous plants, flowers and wildlife are at its heart and in its spirit, from the ancient banksias and red gums to the ever-present call of the black raven.

THE
BEGINNING

'A veritable Garden of Eden'

CHAPTER TWO

BY 1841, MELBOURNE HAD BEEN established for six years and already there was a movement towards instituting a botanic garden. The new township had grown rapidly and its successful merchants and professionals felt the need to emulate the civilised qualities of their mother country, Great Britain.

Although it boasted shops, merchants, dealers and master tradesmen – already a strong middle class to its 6000 inhabitants – Melbourne was still only a little village. A village in the physical sense, but populated by a pioneering community. Melbourne – or Port Phillip, as it was originally named – was founded by free settlers, but was still part of New South Wales. Transportation of convicts had officially been abolished in 1840, but a large number of ex-convicts lived in Melbourne and its surrounds, which caused friction for the rapidly growing body of free settlers. A mixture of tradesmen, farmers and unskilled workers, these immigrants were forthright, practical and determined men of decision and action, and had already made public opinion a factor to be reckoned with.

Probably the last item on a list of what to create in this rough and ready place would be a botanic garden. Teams of new arrivals were stretching the resources of both the settlement and its administration. Amenities were in short supply. The township had been established at the expense of its surrounds. Slaughterhouses were being built along the banks of the Yarra River and released their toxic wastes into water already contaminated with other polluting wastes and sewage. The few streets were dusty and smelly. As the new settlers penetrated further into the surrounding bushland, the trees were rapidly cleared to make way for poor roads and drainage. Blackwood trees *(Acacia melanoxylon)* – commonly called wattle or mimosa – were cut for furniture-making; its timber steamed well and was used by settlers for carriages, boats, barrels, gunstocks and, later, soundboards for pianos. Black She-oak *(Allocasuarina littoralis)* burned evenly and was in great demand for bakers' ovens. Its ash was found to be a good substitute for lye, used for cleaning the printing presses of the fledgling newspaper industry. The mauve, pea-shaped flowers of the Austral

Indigo *(Indigofera australis)* provided a strong blue dye, while the introduction of stock caused the loss of many varieties of grasslands and tuberous plants.

But even though the roads were poor and the amenities scarce (and money from New South Wales even tighter), the burgeoning populace turned their minds towards a botanic garden. The pursuit of both science and botany was already a popular hobby throughout Victorian England and its colonies. In fact, a few of the town's most wealthy inhabitants had begun to create large, landscaped gardens around their homes.

Though there was a curiosity about Australian native trees, plants and flowers, this unknown flora proved a poor substitute for nostalgic British settlers, who missed having four distinct seasons and the accompanying obvious changes in nature. Leading townspeople began to yearn for the wonderful botanic gardens of home – the Royal Botanic Gardens in Kew, London, and others in Edinburgh, Cambridge and Oxford, as well as many highly landscaped private gardens around the British countryside, which had attracted much public interest and large attendance. The settlers believed that Melbourne could emulate these parklands, which were at the peak of their popularity, and they wanted a botanic garden that could provide a background to all the social rituals and celebrations, pomp and splendour of European civilisation. They also wanted a public garden where they could cultivate indigenous and exotic plants. The free settlers had been financially successful and they wanted their environment to reflect this success.

The first move towards establishing the Gardens appeared as early as 1841. The site chosen seemed obvious: Batman's Hill (near the site of the present Spencer Street Station), which was named for Melbourne's founder, John Batman, who had built his home there. It was an undulating hill of 49 acres situated at the west end of town, awash with flowering trees, plant- and birdlife, and was a meeting place for many residents, who enjoyed the picnics, cricket matches, band recitals and race meetings held there.

Besides suitable soil and climate and natural supplies of fresh water, the area offered plenty of landscaping potential. The Melbourne Town Council sent

proposals for setting up a botanic garden to George Gipps, Governor of New South Wales, whose approval was necessary as the Port Phillip District was part of New South Wales. Gipps seemed interested at first, but bureaucracy has its own way of delaying even the most pressing of decisions. Even though the Colonial Secretary's Office in Sydney was enthusiastic, Gipps had concerns. Who was to pay for the new Gardens and its staff? There were political problems as well. Sydney's Botanic Garden was formed purely to raise food supplies for the large number of convicts and the troops who controlled them. Melbourne, however, didn't have these pressures. Why should Sydney pay for Melburnians to have a pleasure spot – and one that would cost more than their own to run?

Luckily, support was forthcoming, and the Mayor of Melbourne, Henry Condell, made a formal application on behalf of his council to the Superintendent of the Port Phillip District, Charles Joseph La Trobe. Although the original petition for land at Batman's Hill failed – perhaps because of other more pressing needs for the land – the decision to involve La Trobe proved inspired.

Descended from French Protestants who had emigrated first to Holland and then to England and Ireland, La Trobe's grandfather and father were deeply religious and highly educated. Both were missionaries (as well as accomplished musicians) and La Trobe's father, Christian, was very involved with English anti-slavery societies.

It was in this religious and cultured environment that Charles La Trobe grew

"Plants were labelled with their scientific and popular names on iron labels that had been brought out as ship's ballast."

up. Born in London in March 1801, he was at first a teacher and might have even followed his father into the ministry, but left England to work as a tutor at Neuchatel in Switzerland. Here, he became a great hiker and mountaineer and wrote the first two of his four travel books. (The latter were written about North America, which he visited in 1832–33.)

La Trobe was introduced to government work when he was sent by the English Government to report on ways of helping the emancipated West Indian slaves adjust to freedom. This probably helped him secure his future position as Superintendent of Port Phillip, as one of the principal tasks of the post was the supervision of the Protectorate system for the 'protection and civilisation of the Native Tribes'. He moved to Melbourne in 1839 to begin his new role. An amateur botanist, geologist, painter and musician, the lean and youthful-looking Superintendent La Trobe was highly regarded by both local Melburnian and English authorities and corresponded regularly with an assortment of botanists. He had adopted from his father a habit of always carrying with him a sketchbook and a botanical glossary.

La Trobe believed strongly in the idea of a botanic garden; in fact, he looked far into the future and also made provision for the establishment of the Carlton and Fitzroy Gardens, as well as the first Royal Melbourne Hospital, the University of Melbourne and the Public Library of Victoria. He made room for the intellect and the aesthetic at a turbulent, difficult and volatile period of Victoria's history. He was a pioneer in many ways and closely in touch with his time and its needs.

In 1844, La Trobe was 43 years old and had been Superintendent for four years. He was dealing with enormous social problems in a rapidly expanding population. In particular, there was ongoing friction over his approach to both the Aborigines and the convicts, which the Town Council and the general public regarded as much too humane. But, far from allowing the idea of the Gardens to lapse along with the original petition for Batman's Hill, the Superintendent was keener than ever.

The site at Batman's Hill was no longer available, but this did not stop La

THE OLD MELBOURNE OBSERVATORY

Since the first explorers set out to find this new continent, astronomy has been part of Australia's history. By the end of the nineteenth century, Melbourne was home to an astronomical and magnetic observatory to rival the best-equipped institutions in the world.

The Melbourne Observatory was actually the second of its kind in Melbourne. The first had been established in Williamstown in 1853, after an appeal by young surgeon and amateur astronomer Robert Ellery for an observatory to establish local time, both for public convenience and to aid the safe passage of ships to and from the town's port.

Superintendent La Trobe appointed Ellery as Government Astronomer in 1853, the same year Ferdinand von Mueller took over as Government Botanist. Ellery was also president of the Royal Society of Victoria for twenty years, and had a place on the boards of the Natural History Museum, the University of Melbourne and the Alfred Hospital. His articles on meteorology and astronomy in the local papers made him a visible public figure and he (along with Mueller) was active in the first Australian attempts to explore the Antarctic.

Williamstown quickly proved to be an unsuitable observatory site, as growing industry made conditions poor for sensitive astronomical instruments. Degraded buildings even forced astronomers into the unacceptable position of observing the stars from a tent. However, an

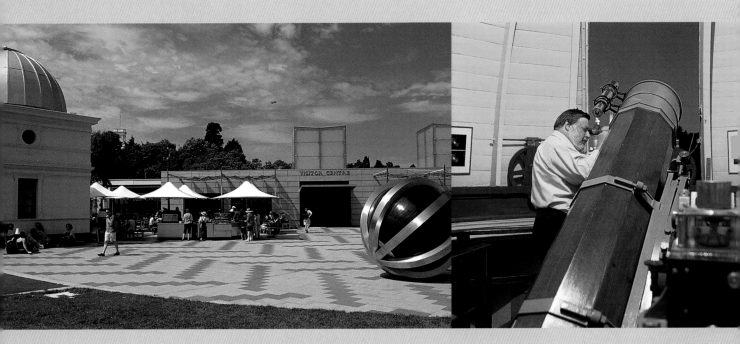

The Observatory Gate complex was redesigned in the late 1990s to include a new cafe and visitors centre. The old buildings where astronomy and meteorology were once studied are still grouped around this popular area. The Gardens offers a Night Sky Tour of the Observatory where visitors can view the planets and stars through the 12-inch reflector telescope pictured above, directed toward the evening sky through a slit in the Astrograph Dome.

observatory was considered of prime practical and scientific importance to the city and so a committee was formed to lobby the Government for a first-rate observatory in gold-rich Melbourne. The Melbourne Observatory opened in 1863, presenting an image of stability and scientific achievement. Located on the borders of the Botanic Gardens (now Birdwood Avenue), this site was chosen as it was near the ports but far enough away from the township to avoid industry and its associated dust and pollution.

As well as providing critical scientific data (essential to the smooth running of a growing number of Victorian industries, ranging from shipping to farming), the Observatory's prime objective was to establish local Melbourne time. It was vital for the shipping trade that ships' chronometers could be accurately 'rated' or calibrated before setting out on a voyage. A chronometer – a type of clock that kept very accurate time at sea – was the key navigational tool. And if ships couldn't navigate reliably, commerce too would suffer. Before the Observatory was established, the newspaper the *Argus* complained: 'Never was a city so doomed to having great varieties of or variations in time as Melbourne: the truth being that there is no true, recognised or proper standard of time in the place.' By the 1870s, the Observatory had relieved the problem by connecting its intricate timing systems, kept accurate by the stars, to a clock in Bourke Street. In 1870, the first telegraph in Australia sent a time signal from the Observatory to the Williamstown timeball. The telegraphs continued each day at 1pm, excluding Sundays.

Data on the colony's climate was collected every day from 1863, at the Observatory and at several rural centres. The Observatory began to provide Melbourne's newspapers with a report on the previous day's weather, until weather patterns began to be understood, and staff began to issue the newspapers with a forecast.

Melbourne's professional astronomers, led by Ellery, were quick to point out that mere star gazing, or looking to the skies for comets, new planets or other celestial bodies, didn't occupy the nights of professional astronomers, romantic though it may seem. 'There is no such thing as star gazing in a regular Observatory,' Ellery wrote. 'Every observation is for a particular purpose and set out beforehand.' These professional astronomers took precise, repeated observations of the stars to maintain correct local time, give public time signals, survey the southern sky and set the longitude of Australian borders and cities. As the reliability of ships' chronometers improved and navigational methods evolved, the primary tasks of the Observatory gradually moved from time to astronomical science, such as mapping the southern skies.

Eleven years after it was established, the Melbourne Observatory had already gained a reputation as one of the best in the world. Perhaps the only person who wasn't happy was the Observatory's close neighbour, the Gardens' Director, Ferdinand von Mueller. Strapped for Government cash and struggling to maintain his Herbarium, Mueller resented the large amounts spent on an elaborate building and expensive equipment, which

thwarted his plans for planting and even blocked his view of the city. To add insult to injury, Ellery was paid twice as much as Mueller.

The Photoheliograph House – a photoheliograph takes photographs of the sun – was constructed in 1874 to record the transit of Venus, which occurs when the planet Venus passes directly between the sun and the earth. Astronomers hoped that by observing this rare astronomical phenomenon they could calculate more accurately the distance between the earth and the sun.

A magnetic observatory was built in 1877, on Observatory Grounds, following a move from Flagstaff Hill. Housing sensitive magnetic and meteorological equipment to record the changes in the earth's magnetic field, Magnetic House was constructed without iron, even though this was one of the most commonly used building materials of the day. Iron's magnetic properties interfered with the instruments recording hourly changes to the earth's magnetism. The Magnetic House currently on this site is the last of three to be built here.

Perhaps one of the Melbourne Observatory's most exciting projects involved the largest scientific undertaking of the nineteenth century. In 1887, Melbourne joined an international project where eighteen observatories were to make a photographic record of the whole sky – an estimated 40 million stars. By accurately recording and mapping star positions, future astronomers could easily detect changes in the night sky. Second Government Astronomer, Pietro Baracchi, described it as 'our heritage to the future generations of astronomers'. The Astrograph project, as

it was called, led to the appointment of the first female observatory staff, with several young women hired and trained as 'human computers' to do calculations. Baracchi, who was in charge of hiring the women, found that not only were they efficient but they could be hired on lower salaries than men. Because of the public service ruling that married women were not allowed to remain employed, Baracchi had to keep replacing the staff. At one stage there were 30 women working on the project.

Melbourne's part in the Astrograph project was originally estimated by Ellery to cost £4000 and take several years to complete. In 1889 a specially designed telescope, camera and building (Astrograph House) were purchased and by 1911 most of the photographic work had been done. But economic depression and war left staff numbers diminished and costs escalating. Although all of Melbourne's catalogues were eventually published, the maps of the sky were never completed because of the enormous cost of printing them.

The Observatory handed over its meteorological studies to the Commonwealth Bureau of Meteorology in 1908 and, with the removal of the most public aspect of its work, the wheels were set in motion for its closure. It eventually closed in 1944, its responsibilities taken over by the Commonwealth observatory at Mount Stromlo, Canberra, to service the whole country.

Today, the Old Melbourne Observatory is open to the public, who can participate in organised tours and peer through old telescopes and gaze upon a sky that so many astronomers have puzzled over. ◉

Trobe or the Melbourne Town Council. Towards the end of 1844, they drew up another petition to Gipps, pointing out that:

> It is of vital importance to the health of the inhabitants that there should be parks within a distance of the town where they could conveniently take recreation therein after their daily labour [and] that experience in the Mother Country proves that where such public places of resort are in the vicinity of large towns, the effect produced on the minds of all classes is of the most gratifying character; in such places of public resort the kindliest feelings of human nature are cherished, there the employer sees his faithful servant discharging the higher duties of a Burgess, as Husband, and as a Father.

The petition concluded with a request 'to set aside as places of public recreation and amusement two portions of land of 500 acres each, the one in North and the other in South Melbourne, and that the conservation thereof be vested in the Town Council of Melbourne'.

Governor Gipps raised no official objections to the reservation of the land but insisted that the financial obligation for the purchase remain with the Town Council. Again, the plan was shelved by the New South Wales administration, but this time not for long. Along with the city leaders, the growing populace demanded a botanic garden and their cry was taken up by the newspaper of the time, the *Port Phillip Gazette*.

A petition headed by the Lord Mayor with around 400 signatures was presented to Governor Gipps. The petition sought immediate action for the availability of funds – a wise move, as developing and maintaining a botanic garden is an ongoing expense. This time, the petition was successful and a sum of £750 was voted for the use of the Gardens for the financial year 1845–46. The hunt for the perfect site began.

Osage Orange (Maclura pomifera).

Credit is given to Superintendent La Trobe for finding the present site of the Gardens. He knew what he was searching for: an area of land that not only was suitable for

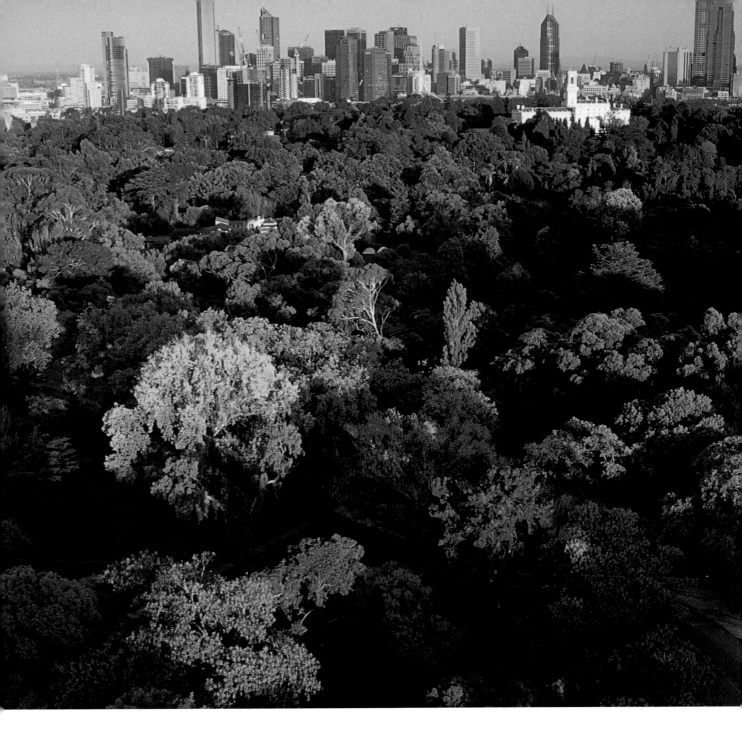

The Gardens at sunrise. The site originally proposed for the Gardens was Batman's Hill, but it eventually found its home south of the Yarra River in a spot described by Superintendent Charles La Trobe as 'a veritable Garden of Eden'. The site was then half a mile away from Melbourne but is now close to the heart of the city.

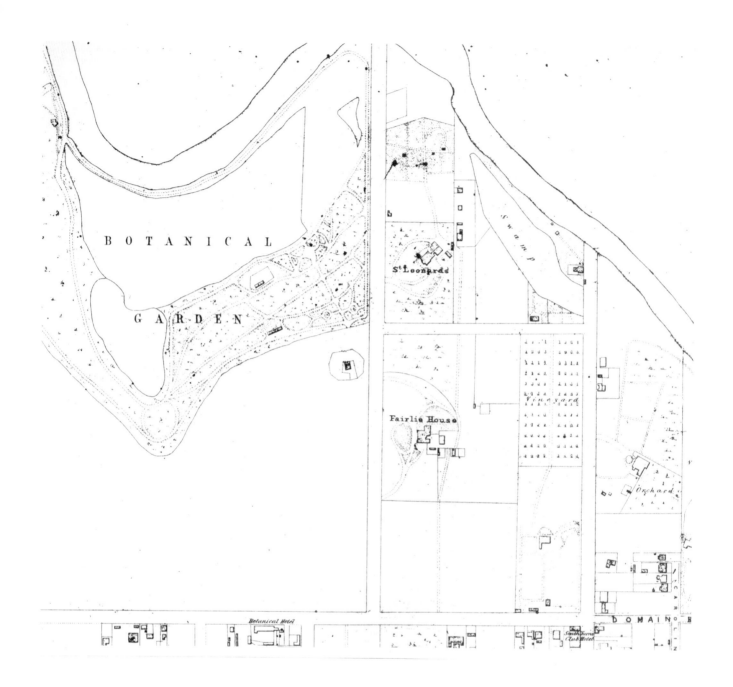

The first landscaping plan of the eastern section of the Gardens, by Henry Ginn, Colonial Architect, in April 1856. (Library, RBGM.)

horticulture and landscaping but was also close by and accessible to the township and its newer suburbs.

After inspecting many potential sites both near and not so near, he found what he was after on the south side of the Yarra River. The site was reasonably close to town – about half a mile east – and seemed to fill the other prerequisites: the land undulated and ran down to the river, and its fine black soil held much agricultural promise. Not only that, it was naturally beautiful, with its graceful River Red Gum (*Eucalyptus camaldulensis*), Red Box (probably *E. polyanthemos* or *E. goniocalyx*) and She-oaks (*Allocasuarina verticillatta* or *A. littoralis*) and wattles. Banksia and eucalypt trees spread over the flats, its sloping hills were covered in Kangaroo Grass (*Themeda triandra*) and thick shrubby plants lined the riverbank. The whole area was densely covered with Swamp Paperbark (*Melaleuca ericifolia*) and embellished by scrub vine (*Cassytha melantha*). A gently sloping natural amphitheatre provided a haven for wildlife, with its clumps of Tall Sword-sedge (*Lepidosperma elatius*) and Native Bulrush (*Typha orientalis*), while a small stream flowed into a lagoon. 'If you will come with me I will show you a spot, which in my opinion, is infinitely superior for the purpose of a Botanic Garden to the one previously spoken of … a veritable Garden of Eden,' La Trobe wrote in his committee's report to the Town Council.

The area was well known to local administrators as the site of the first Aboriginal mission station in Victoria. George Langhorne, the 'Government agent for the civilisation of the Aborigines', had set up a mission station nine years earlier on 362 hectares that extended southeast along the Yarra River. The mission, which included a school, began operating in 1836 under the control of Langhorne, who had been sent from Sydney to 'look after the moral and religious training of aborigines'. It remained open and active until 1841, with some 700 men, women and children living within a 48-kilometre circuit of the township being enticed there. Now, however, but for the spirits of Koories past, the land was unoccupied.

La Trobe recommended to the Melbourne Town Council that a committee be formed to administer the Gardens, with members who had the

Overleaf: Very early in the Gardens' development it was recognised that a small creek from South Yarra running into the lagoon could form the basis for a tree fern gully. More than half the species in this moist gully are Australian natives, including many rare and threatened plants. Since this photo was taken, however, Fern Gully has sustained considerable damage from the colony of flying foxes that has made its home there (see p.140).

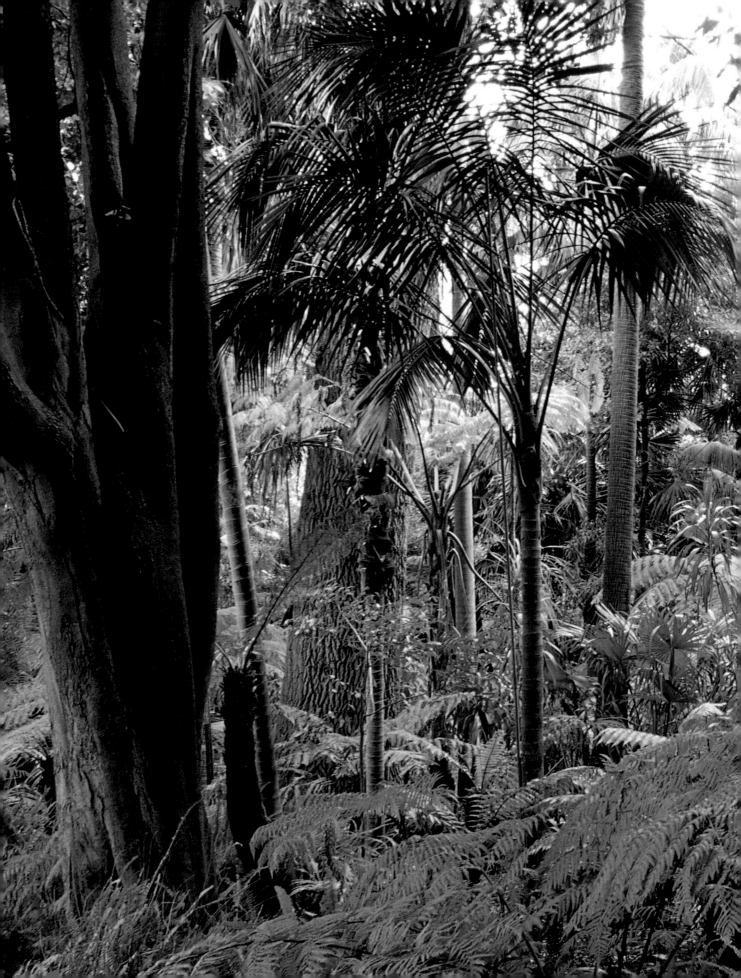

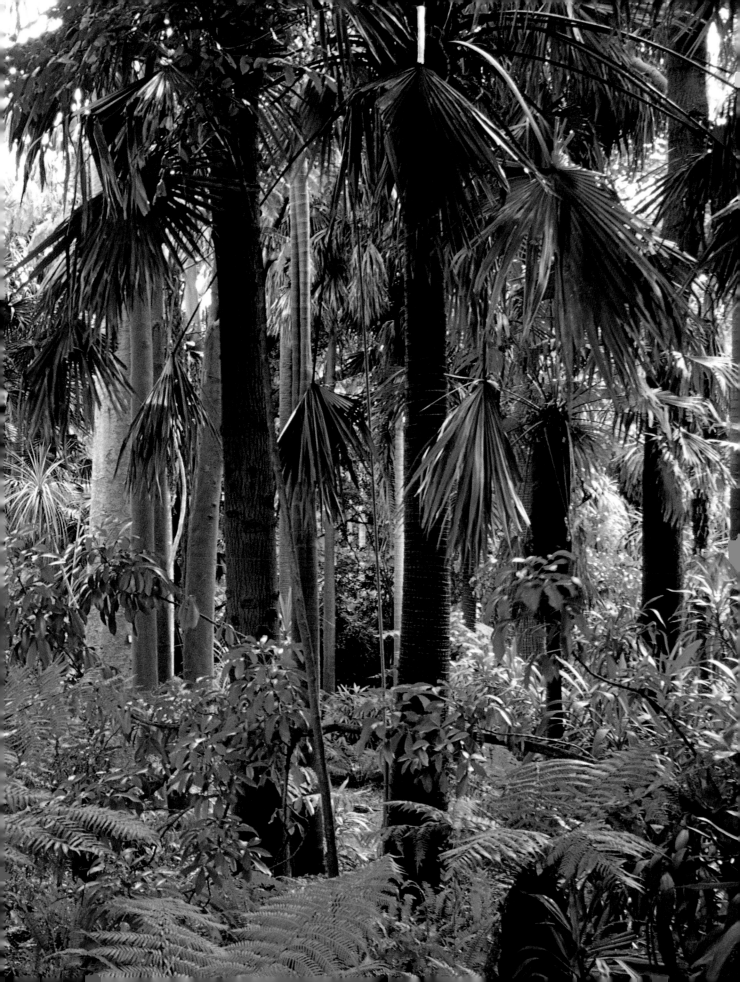

administrative and/or botanical science skills to ensure that any development would not be inhibited by a lack of skill or imagination. Or, as he put it, men 'of acknowledged activity and talent, irrespective of connection with the government or otherwise'.

The committee he eventually appointed included Captain William Lonsdale; the Mayor of Melbourne, James Simpson; the Manager of the Bank of Australasia, D. C. McArthur; and medical practitioners E. C. Hobson and Godfrey Howitt, both of whom had an interest in the natural sciences, with La Trobe serving as an ex-officio member. The committee's inaugural meeting in February 1846 allocated £750 towards a gardener's cottage, and made decisions to fence the reserve with a four-rail fence and erect a paling fence around the nursery ground, to draw dead timber together, to clear, grub and trench and clean out the lagoon. The rest of the initial funding was to be spent on salaries for a superintendent and two assistant gardeners, equipment by way of gardening tools, frames and horse and cart and water cart. It was also agreed that staff be employed as soon as possible.

The first Superintendent of the new Botanic Gardens was appointed by the committee in March 1846. John Arthur was a Scottish botanist and landscape gardener, who had graduated with honours in his field and had been head gardener to the Duke of Argyll. Arthur had migrated to Australia with his wife and four children seven years earlier and had been employed immediately on arrival by a Captain Smythe to look after his property in the country, at a rate of £80 per annum, a salary twice as much as the going rate at the time. During this time he also set up a nursery in Heidelberg with plants and seeds he had brought with him from Scotland. His specialist knowledge and interest in horticulture quickly attracted La Trobe's attention.

After his appointment, Arthur camped in a tent in the Gardens, while his family lived in temporary quarters on the site of the present Windsor Hotel in Spring Street. He soon made his first request of La Trobe: permission to build a hut for accommodation, as well as a larger hut for the preservation of seeds and tools.

The first official task of the new Superintendent of the Botanic Gardens was

the fencing and development of an area of approximately 2 hectares adjoining what is now Anderson Street on the east and running down in a northerly direction to the lagoon adjoining the river (the present Ornamental Lake). This area was chosen because La Trobe was anxious to have some well-maintained space on which to hold official garden parties. He believed that this was the best

PEOPLE OF THE GARDENS
A squatter named Gardiner

Until recently, some gardeners and the Director lived on site at the Botanic Gardens. One of the first to live there was a squatter named Gardiner, who lived on a portion of land from before the Gardens were started.

He kept cows, whose milk was sold to a growing Melbourne population. One of the daughters of John Arthur, the first Superintendent of the Gardens, recalled that in 1849, aged eleven, she would walk to the squatter's house every day from the lodge, in what is now Anderson Street, South Yarra, for milk for her family. Traces of the old dairy remained evident in the Gardens until about 1900. It was positioned near the pathway down the Hopetoun Lawn.

way to meet the populace of Melbourne, and demonstrate to them that their wish for a Botanic Gardens was finally being met. Henry Ginn, the Colonial Architect, drew up the original plans for this work. Nothing exists of those original plans but they would probably have been developed along the landscaping lines of the English garden on a grand scale.

Problems soon arose with the untrained Gardens' staff. Arthur was forced to sack all of the men working for him because of unsatisfactory service. He was given permission to hire new staff and, with the assistance of his daughter

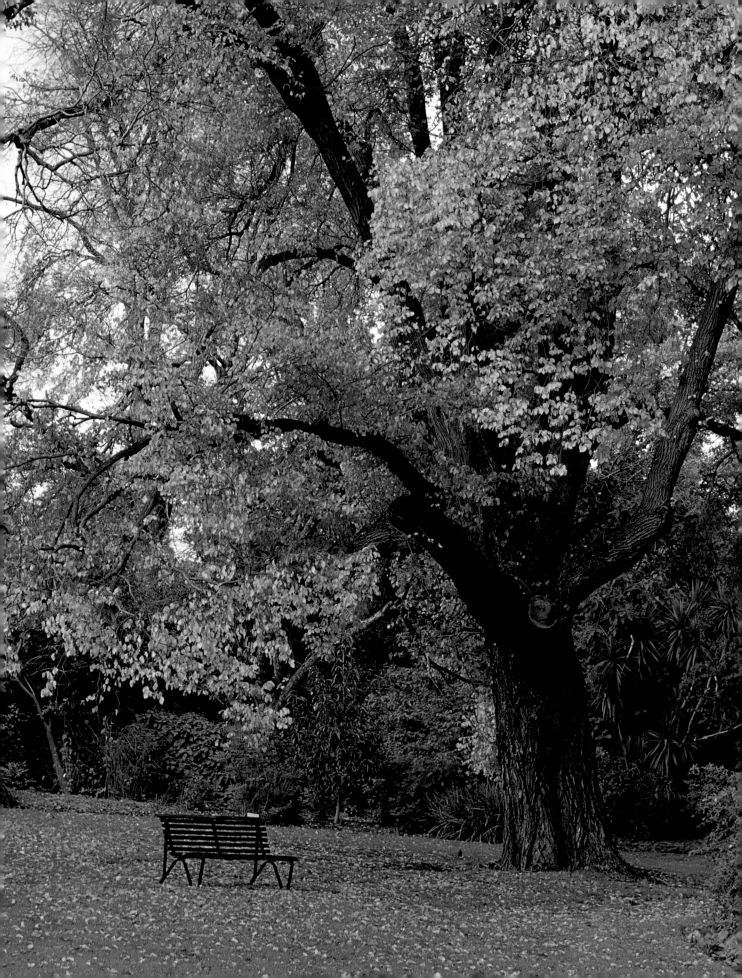

Grace, the first plantings of trees were made during the winter of 1846, under Ginn's direction and according to his plan. The trees, like most of the plants Arthur introduced, came from his Heidelberg nursery. Two of the elms (*Ulmus procera*) planted that winter (now known as Arthur's Elms) are still alive.

John Arthur died in January 1849, aged 45. It was said that his death was caused by cholera, which he probably picked up from drinking the contaminated water of the Yarra River. He had set a high standard: Arthur was the one who laid out the first lagoon walk below the propagating houses, built the first enclosure for planting and, under La Trobe's directive, established lawns for those garden parties – all with limited budget and means.

His death shocked those around him and left an upset La Trobe to find a suitable replacement, a man whose training and experience would consolidate the work that had been already carried out and build upon it. He chose another Scot, John Dallachy.

Plants fascinated John Dallachy, whose real love and expertise lay in collecting new specimens, especially those from New Holland, for Haddow House (the seat of the Earl of Aberdeen), where he worked first as junior gardener and then as head gardener. It was here that he gained landscape experience. When Dallachy migrated to Melbourne, armed with an introductory letter to La Trobe from the Governor of Ceylon, he found immediate employment as head gardener for the 2.5-hectare Italianate/English landscape garden of J. B. Were's home, Moorabbin House, in Were Street, Brighton.

La Trobe employed Dallachy as Superintendent not long after his arrival. His title was shortly changed to that of Curator, which was considered more appropriate to the standing of this position within the community.

In Dallachy's eight years as Curator, he increased the number of plant species to 6000 – 1000 of them native plants, many collected during his trips into the countryside around Mount Macedon, the Rutland Hills and along the Yarra River. Three of his specimen trees – the *Araucaria excelsa* (now *A. heterophylla*), *A. cunninghamii* and *Sequoia sempervirens*, planted close together in 1851 on what

*Left: One of the two surviving elms (*Ulmus procera*) planted in 1846 by John Arthur, the first Superintendent of the Gardens. The trees have long been known as Arthur's Elms.*

is now the Eastern Lawn – still exist and are now regarded as trees of great historic importance.

Within a few months of Dallachy taking up his new position, about 2.4 hectares of the site had been cultivated, fully trenched and nearly all planted. A border had been built around the margin of the lagoon and a 550-metre walk was made and gravelled. Walks were also formed from the western gate leading to the cultivated part of the Gardens; one walk took visitors along riverbanks, while the other led them across a rustic bridge over the west side of the lagoon.

After visiting the Gardens in 1853, William Howitt wrote in his book, *Land, Labour, Gold*:

> The garden is finely situated at a bend in the river, so that it slopes up to a considerable height above it in a fine sweep. These slopes are laid out in very good taste in walks, including large beds planted with all kinds of native and foreign shrubs, trees and flowers that will flourish in the open air ... To me, the walks about the garden were a real delight. One was obliged to walk from the paucity of seats, but that was the less consequence as the natural charms of the place induced one to walk on. The sun was bright, the air delicious, the shrubs all around us were full of flowers and fragrance, the lake, or lagoon, at the bottom, covered some acres of ground, looked wild with rushes and aquatic plants, and a good portion of it occupied with a jungle of tree-scrub.

Dallachy began a 'system' garden, where plants were displayed according to their biological relationships. Plants were labelled with their scientific and popular names on iron labels that had been brought out as ship's ballast. (Many of these labels still exist.)

The lagoon was excavated and deepened and made more ornamental during Dallachy's tenure. This was the first of many similar operations undertaken to overcome siltation problems caused by the run-off of excess water from the neighbouring slopes, and flooding from the river, which occurred regularly for many years to come.

Large plant beds were built on either side of the rustic bridge. A propagating glasshouse was constructed in the southern portion of the Gardens to house the ever-increasing amount of material collected from the Curator's field trips and sent from England. Alongside this glasshouse, a tea-tree-lined pit was dug. In here young plants could be hardened before being planted out. The pit also provided plants with shelter from the summer heat.

Initially, Dallachy worked under difficult conditions. There weren't any nursery buildings and he had to improvise by making his own huts of brush. It was the beginning of the Gold Rush and labour was short, which slowed down work considerably. The summer of 1850–51 was excessively hot and resulted in drought conditions. It was also at this time that Scottish Milk Thistle (*Sonchus*) made its appearance in considerable numbers. The eradication of the thistles was probably one of the first recorded instances of successful weed control in the new colony.

At the end of 1853, another 2 hectares of the Gardens had been cultivated and planted. The number of walks (some of which became the basis of the present system) were increased. Underground drains had been constructed, the rustic bridge pulled down and rebuilt, and the ground for the cultivation of bulbs fenced off. A small section of the lagoon was also fenced off for the swans.

Dallachy's expertise in native plants was noticed and appreciated. An 1853 description from the English journal *Gardener's Chronicle* showed considerable interest in his work:

The trees and shrubs are planted promiscuously, native and exotic, heedless of class or order, and interspersed with a good sprinkling of herbaceous plants, and florists' flowers for show. The gardens contain a good collection of what in England are termed New Holland plants, such as the different species of the Gums, Acacias, several of which have not yet been introduced into Europe, having recently been found in the interior of the country, Polygalas, Corraeas, Cassias, Billardieras, Callistachys, Eyrybias, Araucarias, &c., and some very large plants of Agave Americana.

But Dallachy's interests drew him back inexorably to collecting, particularly native plants, both for the Gardens' use and for herbarium material. He had a strong association with a Dr Mueller, a chemist and botanist who had started sending new specimens as early as 1849. Dallachy and Mueller became great friends and made several field-collecting expeditions around Victoria.

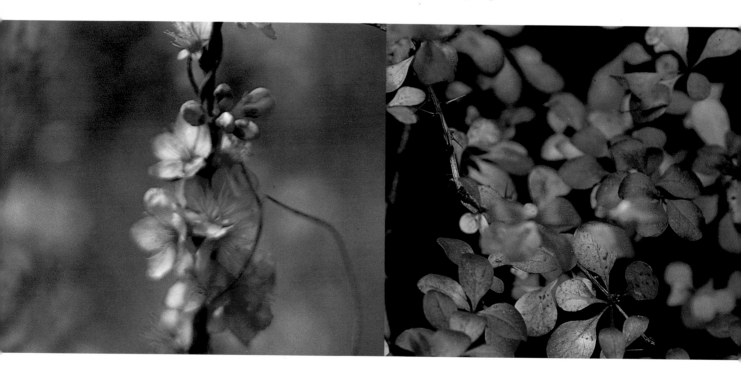

Left: Prunus blossoms (Prunus tenella).

Right: Berberis (Berberis thunbergii *'Atropurea'*).

Up to this time, botanic identifications were either being made by amateur botanists or forwarded to Kew Gardens in England. But now the need for a Government Botanist had become obvious, and in 1853, La Trobe appointed Mueller to the position. As Dallachy was away so much, Mueller became more and more involved in the Gardens' administration.

Eventually, Dallachy's enthusiasm for fieldwork became all-consuming and, in 1857, Mueller superseded him as the Gardens' first Director. This didn't

interfere with their friendship, and Dallachy continued to act as a paid field collector and assistant under Mueller, at a much reduced salary.

When Dallachy left his position, the plantings included 32 species of *Acacia*, ten species of *Grevillea*, nine species of *Hakea*, eleven species of *Pultenaea*, four of *Eucalyptus* and there were an appreciable number of native

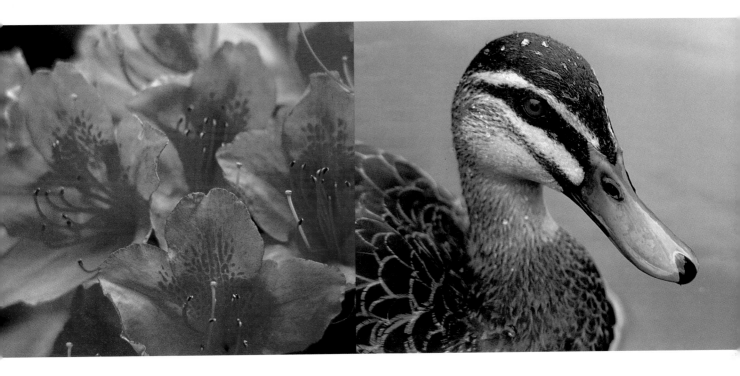

orchids thriving in the Gardens – and this at a time when most visitors wanted to see European plants.

In 1862 Mueller suggested that Dallachy transfer to Queensland (Mueller had a special botanical interest in the northern regions of Australia), where he could collect exclusively for the new Herbarium that was being developed. Dallachy accepted the position and continued working in this capacity until his death of typhoid fever at a station near the shores of Rockingham Bay in June 1871.

Left: Azaleas
(Rhododendron, Azalea).

Right: A resident of
Nymphaea Lily Lake.

PEOPLE OF THE GARDENS
Dorothy and Alex Jessep

Dorothy Jessep was born in 1894. She lived in the Botanic Gardens with her husband, Alex Jessep, from the year he was appointed its Director and Government Botanist in 1941 until he retired in 1957. Alex Jessep was internationally recognised for his research into camellias and roses and received many awards and medals.

'After Alex's appointment, I went over and took a look around Gardens House properly. I didn't want to move there. It looked dreadful, with no paint on the outside, and it was very crude inside. In the kitchen, there was a fire stove and awful gas stove and a frightful sink and no cupboards anywhere … [but] we made it presentable and we became very happy there … A few families were living in the Mews [at Government House] and some had children and Rosemary [Dorothy Jessep's niece] would often visit and play with them. We had quite a community happening, what with Government House and the Garden staff.'

'I used visit Mrs Rae at the Director's residence, when her husband, Frederick Rae, was Director [1923-41]. Mrs Rae was an amateur actress and very clever. She used to entertain a lot in the house and I think she was responsible for opening up the front and making it more spacious. She had it all furnished in black and white and she used to call it the "Dower" house. Whether she meant the "dowager's house", I'm not sure. I wasn't up on dowagers then, but I know I am one now. Mrs Rae was a very good actress. She used to laugh about going to rehearsals and always carried a hat pin with her, as she used to walk across the Domain at night. I was never frightened about living in the Gardens, although we

did have the wrought iron door put on. Alex went out quite a lot, as he used to give talks in those days at night, and I liked to have something between myself and the people on the other side.'

'It was the Second World War and there were severe staff shortages at the Gardens … Trenches were being dug outside near the Shrine and the government wanted to dig trenches in the Gardens as well, but Alex didn't approve of that. We had word from Government House that they had dug trenches and, should we be bombed, we could share the Government House trenches. The trenches in the Domain were for the boarders at nearby Melbourne Grammar School. The trenches all around the Shrine were for everyone. Then the Americans arrived and took over the Herbarium and all the plants and valuable things – precious things, such as the samples that Joseph Banks brought out – were taken out and stored in the shed at the nursery. We all had to just make do … Staffing during the war was a terrible problem. We were very, very short of gardeners. The workers we had were hopeless, and Alex had a terrible time but, fortunately, he had a very good head gardener in Mr Gray, who was an excellent man. Every morning at 9 o'clock they would meet at our gate, Garden Path Gate, and he and Alex would do a section check on everything. Alex really held Mr Gray in high esteem.'

'Queen Elizabeth II was the first reigning English monarch to plant a tree in the Gardens. It was quite an informal arrangement. Alex, along with Mr Crawford, the Minister of Lands, witnessed the planting and I think Mr Gray as well. They all walked up the path in the Gardens to where that little private gate is and met the Queen. She came out in the simple floral frock and no hat and she had Lady Mountbatten with her . . . It hadn't been announced because she didn't want crowds and people were passing her and not recognising her, and Pamela Mountbatten said to Alex, "Look at the people all walking past and they have no idea who she is." The Queen came down and they had the hole ready and she took the spade and planted the tree and Rosemary presented her with flowers and then she went off again. It was just a very simple arrangement.'

'We saw quite a few dignitaries come and go. Governors, of course, they planted trees too. Alex planted a tree but I never saw him planting it, he must have done it quietly. Every time Lady Gowrie [wife of the then Governor General, Lord Alexander Gowrie] came down from Canberra, she would ring Alex up and say, "Are you ready for a walk?" She was a very keen gardener and Alex would go to Government House at the little gate and meet her and they would walk as far as she felt like it. Lady Gowrie had a blue garden up at Canberra and she would ask Alex, "Anything new in blue?" hoping there would be something to add to it.'

'We used to go a lot of functions. When the Queen was at Government House, we went to one of the functions for her and, coming home in the car, we went up to the corner of the Herbarium and Dallas Brooks Drive. The police were all standing there, and as we took the turn in, they wouldn't let us through as we hadn't got a pass. We were in evening dress and, you see, Alex only had his single keys with him, so we had to drive around to Anderson Street before we could get in a gate there and then drive home through the Gardens. They didn't like the look of us!.'

'In those days, we only had a small camellia collection at Burnley College. Professor Waterhouse [the famous horticulturist and linguist, who was the originator of the Camellia Garden near Sydney] wrote to Alex, suggesting he might come over to Melbourne and have a look at the camellias, which he did . . . He found 138 varieties and he was very impressed. Alex named some of his camellias for staff — in fact quite a few — and there is one named after me. It is just a red one, it is quite a big tree and it is called the "Dorothy Jessep". It is not a very special one, but it's pretty.'

'Helen Keller was staying in Melbourne with her companion, and she came over to the Gardens. Alex took her down to the lake and explained about it all. He would take her to a tree and she would feel the texture of the trunk and she would put her arms around it and they would give her a leaf and she would feel the shape of the leaf and then she would bite it, to get the taste of it.'

'In our day, the Gardens staff had a lot of crude things to work with. The men swept with birch brooms. And there were horse-drawn lawn mowers, which offered children tremendous excitement. The children loved them, those two spanking horses pulling the mower, so in a way it really was a shame that it had to end. The horses were stabled at Government House, where, I think, they were used to mow the lawns as well. The Police Department used the manure.'

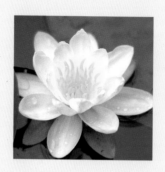

BARON FERDINAND VON MUELLER

'An establishment for the diffusion of knowledge'

CHAPTER THREE

BY THE TIME THE YOUNG PHARMACIST and botanist Ferdinand Mueller arrived in Melbourne in 1853, the village of Port Phillip had been transformed by the discovery of gold. Prospectors from around the world were crowding the dusty streets; horses, wagons, ox carts, and men on foot, all heading towards perceived fortunes, choked the roads to the goldfields.

The township itself was bursting at its seams. Its port at Hobson's Bay was crowded with tall ships from near and far; that year, the ships brought in more than 100 000 immigrants from all around the world. Prostitutes and brothels took their fair share of the diggers' money, and bars were bursting with customers. Horses were shod with gold; at night, drunken crowds filled the streets.

Like all the others, the 28-year-old Mueller had come to Melbourne to make his fortune. But he was no digger. Born in 1825 in the Prussian town of Rostock on the Baltic coast of Germany, he moved to Australia with his two younger sisters in 1847. Both his parents and his older sister had died of tuberculosis. Now the elder of his surviving sisters, Bertha, was showing signs of succumbing to the same disease. Australia offered the Muellers the chance of restored health, as well as a way of starting afresh. But the young Mueller was also attracted to the new continent's unknown and undiscovered flora. His qualifications were in pharmacy and medicine, but his lifelong interest in botany had begun when he was apprenticed to an apothecary on his mother's death.

The apothecary's trade in Germany of the early 1800s was highly organised and strictly supervised. Besides studying French, Latin, Greek and mathematics, as well as laboratory processes, chemistry and business studies, the apprentice was also expected to collect a comprehensive herbarium. The apprenticeship suited young Mueller perfectly. Its requirements of studious solitude and a fascination with the outdoor world matched his personality, and botany's strict methodologies appealed to the taxonomist in him.

Plants still played a basic role in pharmacy, but Ferdinand Mueller had entered the field at a time when new areas were being opened up in science. The study of plants now made possible new solutions to many problems.

Botany, along with many of the other sciences, had taken on exciting possibilities. Modern science had really begun in the eighteenth century when, for the first time, serious studies of the workings of modern chemistry were being made. Chemical experiments were conducted to extract a plant's valuable organic material and oils which in turn were found to have new and important uses in medicine. The use of plants and herbs was no longer based on folklore; they had for the first time become the subjects of close analysis and observation, for their medicinal and financial value.

Mueller's thesis on the flora of southwest Schleswig earned him a degree of Doctor of Philosophy from the University of Kiel. It was as a student that he began his lifelong habits of prodigious and almost obsessive work and prolific written correspondence with botanists and collectors around the world.

Mueller had originally migrated to Adelaide, where there was a large German population. He worked as a pharmacist there, but his real love was botany and he decided to come to Melbourne so he could make enough money to pursue this field professionally. Soon after his arrival, he was introduced to Charles La Trobe, who was looking to fill the position of Government Botanist.

Although still relatively young, Mueller had already developed quite a reputation. In his years at Adelaide, he had undertaken several field-collecting explorations into the South Australian hinterland and Flinders Ranges, mostly by himself and on foot. In the two years before his move to Melbourne, he had begun to publish papers on his discoveries, firstly in South Australia and then in Germany and England. In 1853, his paper 'Flora of South Australia displayed in its fundamental features' was published in *Hooker's Journal of Botany* and *Kew Garden Miscellany* and also appeared in a German botanical journal.

In the highly specialised world of professional botany, Mueller's work had begun to be noted with interest – it was of particularly high quality and his fascination with the plants and flowers of New Holland was unusual.

Mueller made a strong impression on La Trobe, who wrote about him in a letter dated 8 October 1852 to the Tasmanian botanist, R. C. Gunn:

There is an honest-looking German here, Dr Müller, who as far as I can judge seems to be more of a botanist than any man I have hitherto met with in the colony; and I shall give him every encouragt. He has punished me with the description of the genus *Latrobe* of Meisner . . .

Mueller was appointed as Government Botanist for the Colony of Victoria on 26 January 1853. The position required him to carry out research on plants of industrial, medicinal and horticultural value and to describe and classify Victoria's flora. It also ensured his relationship with the Botanic Gardens from the time of his appointment, particularly as its Curator, John Dallachy, was also interested in discovering new species for cultivation.

Mueller moved into the under-gardener's cottage at the Botanic Gardens, then departed almost immediately with Dallachy on a field-collecting expedition to the Victorian Alps. At the end of this first trip, Mueller added 936 new species to the list of native plants known to be growing in Victoria.

His *First General Report of the Government Botanist on the vegetation of the Colony* was submitted in September 1853 to La Trobe, who was impressed with its scope and thoroughness. The report included mention of Mueller's intention to form what is now the National Herbarium of Victoria:

> In accordance with his Excellency's instructions, a collection of dried specimens of plants has been collected for the Government. This herbarium will be at all times accessible to the public, and will hereafter contribute, I trust, to diffuse more and more knowledge of our vegetable world, and excite lovers of natural science to assist in my investigations. I began to form, at the same time, a similar collection for the Royal Gardens at Kew.

This relationship begun by Mueller between the Melbourne Botanic Gardens and the Royal Botanic Gardens at Kew continues to this day.

On 13 August 1857 Mueller was appointed the Botanic Gardens' first Director. He also retained his position as Government Botanist (although didn't receive a pay rise for his extra duties).

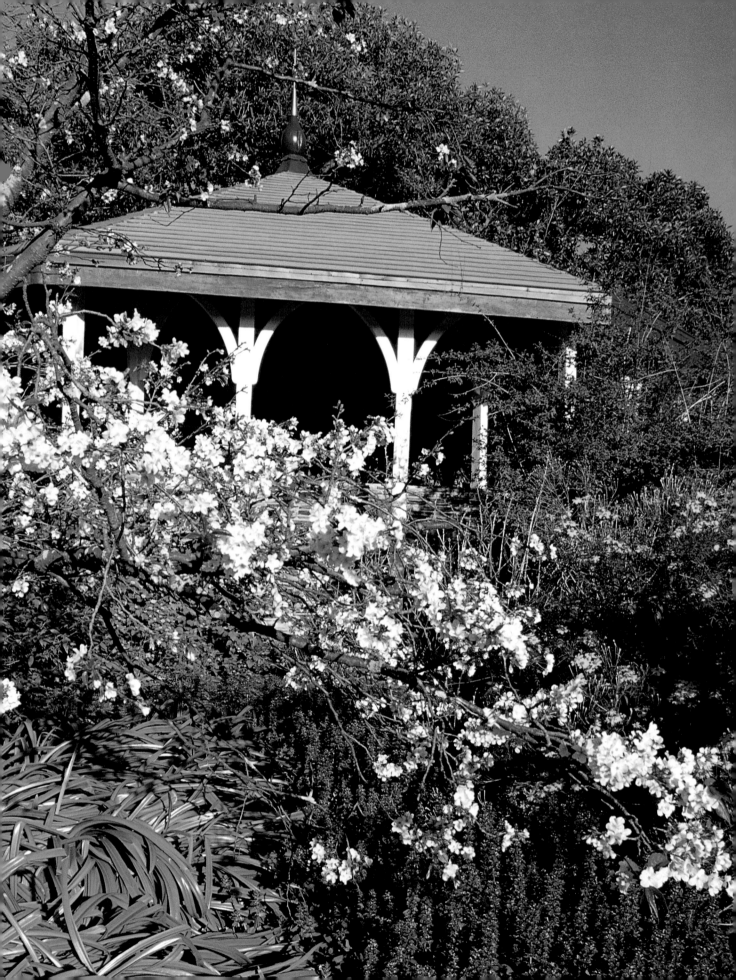

Mueller's appointment began auspiciously. Two weeks after he took on his new role he submitted a report to the government describing the Gardens' conditions and detailing what he hoped to achieve. The report noted that limited funds and staff shortages meant that little new ground had been cultivated – only 1.2 hectares had been developed between 1853 and 1857. However, he added, 'with a view to rendering the Botanic Garden attractive to the public as a place of recreation, the Curator has been endeavouring to increase by ornamental plantation, the natural beauty of the spot'.

His funding was increased and with it more staff were hired. An office and residence (now Gardens House) was built for Mueller, with a commanding view over the Gardens. The first conservatory was erected, as well as additional propagating houses.

The Mueller who moved into his new home in the winter of 1857 was a complicated man. At 32 years old, he hadn't yet married, although both of his sisters were now living their own lives and he was free to do so. Instead, he concentrated on his work. He was prone to bouts of hypochondria and was not much interested in fashionable clothes or manners. Although naturalised, he still spoke English with a thick Prussian accent, and his sense of humour and approach did not always gel in this anglicised community.

Mueller was also a fearless explorer, and had spent months on his own in the outback of South Australia and Victoria. He had climbed alone to the top of Mount Kosciusko, Australia's highest point, and then fallen ill with scarlet fever. He was forced to spend two weeks by himself, but still managed to feed his horses. When he came home he was actually in better health than when he had left.

Despite his eccentricities, Mueller was recognised as one of the country's leading botanists and well respected.

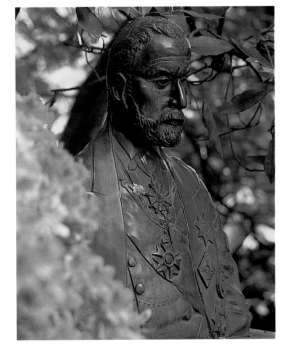

Above: This bust of Ferdinand Mueller stands near the National Herbarium which he founded during his time as Director of the Gardens (1857–73).

Left: Tecoma Pavilion, on the Eastern Lawn.

Mueller's approach to his new role as Director of the Botanic Gardens can be seen in an address he gave some years later (on 23 November 1871) to a Melbourne industrial group on 'The Objects of a Botanic Gardens Relative to Industries'. The speech makes clear what he considered to be the prime objectives of a botanic garden:

> [It] must be mainly scientific and predominantly instructive ... As a universal rule, it is primarily the aim of such an institution to bring together ... the greatest possible number of select plants from all the different parts of the globe; to arrange them in their impressive living forms for systematic, geographic, medical, technical or economic information, and to render them accessible for original observations and careful records.

On his first Victorian plant-collecting expedition Mueller had visited Wilson's Promontory, the southernmost point of Victoria, and been tremendously impressed with its native flora. After becoming Director, he sent one of his foremen, John Walters, to collect large numbers of ferns and other native plants from the area. Walters brought back many unclassified species, as well as specimens of economic timbers and young plants of forest trees.

In the Gardens themselves, Mueller immediately embarked on a project dear to his heart. He devoted 1.2 hectares to a system garden – a large extension of Dallachy's original system garden – where plants were arranged according to a classification system or 'natural system' to demonstrate 'the mutual alliances which connect members of the vegetable kingdom'.

Below the system garden were 30 experimental fruit plots of plants likely to be of economic value to the colony for medicine, food or fibre. Plants such as tea, olive, mulberry, Cork Oak, ginger, arrowroot and cotton were grown. Mueller also experimented with varieties of bamboo, sugarcane and grapes, as well as plants suitable as hedges for enclosing farms and gardens, such as prickly acacias, hakeas, Osage Orange, hawthorn, Cape Broom and prickly pear. Agricultural grasses were sown, while Buffalo Grass (*Stenotaphrum secundatum*) proved successful as lawn grass.

Mueller added 30 species of imported oaks indigenous to Europe, Asia and America, all planted together on the lawn between the office building (now Gardens House) and the storehouse to the south. Although he was primarily interested in experimental, scientific and economic plantings, he was not immune to the beauty of plants. By 1859, he had increased the number of new plants under cultivation to 3300 species.

Flower borders were used around the office, the Palm House and along the south edge of the lagoon. Originally, edges were decorated with chamomile, but its maintenance proved too labour-intensive so, over the years, dwarf roses or Turkish Box edgings replaced it. Shrubs from South Africa and Western Australia were used because of their ability to withstand Melbourne's hot summer winds.

Beautifying efforts were also concentrated on the most highly developed portion of the Gardens – to the east, around the area of the Tennyson Lawn. This was a series of parallel paths that followed the lawn's contours and included a formal parterre garden with circular garden beds. The path system was doubled and made in two different widths – narrower paths to accommodate pedestrian traffic and wider paths for vehicular use – with avenues of exotic trees used to delineate the 'walks' through the natural vegetation.

Mueller increased the incidence of plant labelling. In 1858, conspicuous new iron labels were installed. They showed the plant's botanical and common names, its classification and its country of origin. By 1862, 3000 labels had been

Overleaf, left to right, from top: Pride of Madiera (Echium aff. candicans), Water Lily (Nymphaea), Magnolia (possibly Magnolia campbelli), Chinese Lantern (Abutilon), Flag Iris (Iris germanica), Victoria Gold Rose (Rosa 'Victoria Gold'), Agave flower (Agave geminiflora), Camellia (Camellia japonica), Daisy. Full page: Bird of Paradise (Strelitzia reginae).

"There is an honest-looking German here, Dr Müller, who as far as I can judge seems to be more of a botanist than any man I have hitherto met with in the colony."

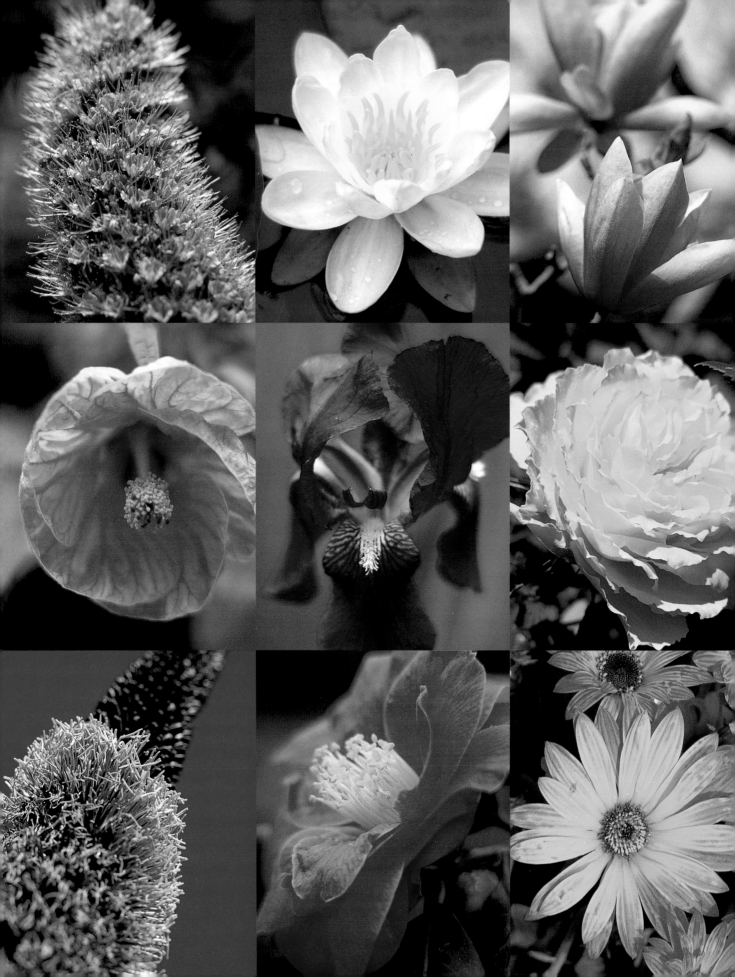

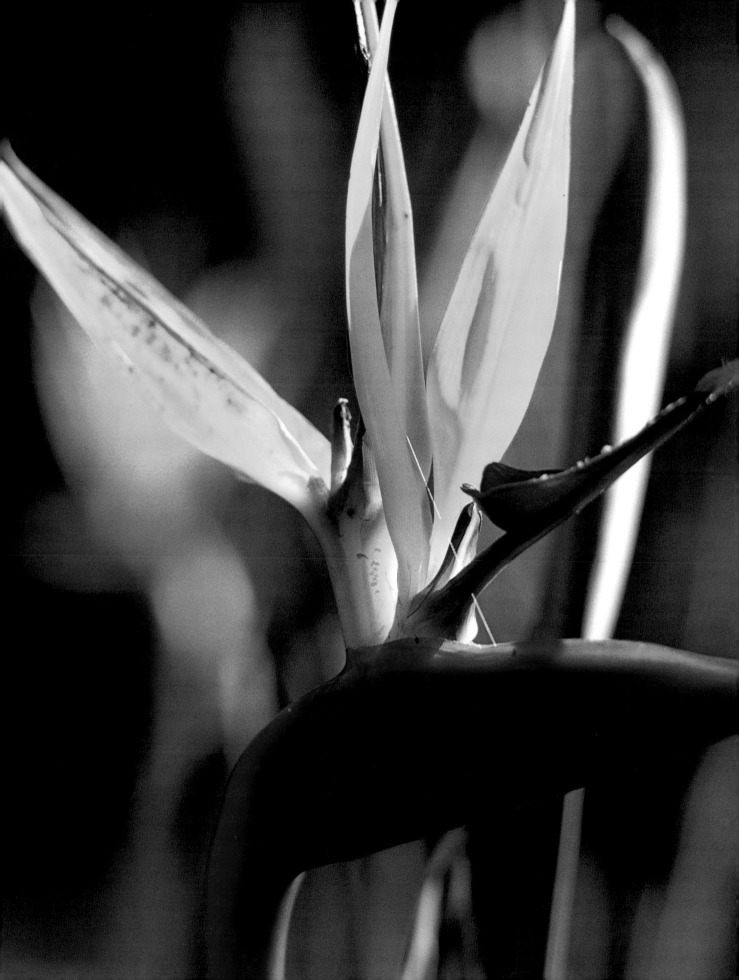

fixed (ten years later these were replaced by more 'sightly' porcelain labels).

The numbers of visitors to the Gardens had been steadily increasing, and Mueller well understood the importance of providing entertainment as well as relaxation and instruction. The Palm House and a bandstand were built, and across the river, an aviary and a menagerie were added – these two were peculiarly nineteenth-century in their concept.

The menagerie – or Zoological Garden – was incorporated in 1859 with Mueller as its Director in addition to being Director of the Botanic Garden and Government Botanist (once again with no increase in salary). Designed for the collection and study of species according to scientific principles, the zoo was built to resemble those in Britain. It was small and overcrowded, with pretty much no attention paid to its inhabitants' individual needs. The main animal enclosures were in the north and south reserves; in 1859, a llama–alpaca flock from Britain and a small flock of angora goats were imported. In fewer than two years, these nineteen llamas had increased to 37 and were expected to increase to at least 50 by the following year. Space eventually became a real issue, so in 1861 the animals were transferred to Royal Park.

In that same year, the Acclimatisation Society of Victoria was founded. Its enthusiasts believed that Australian flora and fauna were ugly, and they felt deprived of England's birds, animals and plants. By introducing these species here, they felt they could create a perfect home environment – one that was more visually reassuring than the unknown varieties in their new homeland. Accordingly, the Gardens' aviary was built for breeding English songbirds such as song thrushes, larks, blackbirds, starlings and canaries. Eventually, seventeen pairs of song thrushes, eight pairs of blackbirds, three pairs of starlings and twelve pairs of skylarks were released right around Melbourne and as far away as Phillip Island so they could attempt to acclimatise. (The birds also ate practically everything in sight.)

The Director's successful cultivation and the subsequent flowering over four seasons of the royal water lily, *Victoria regia* (later known as *Victoria amazonica*), also brought in the crowds. The plant had six floating leaves, which

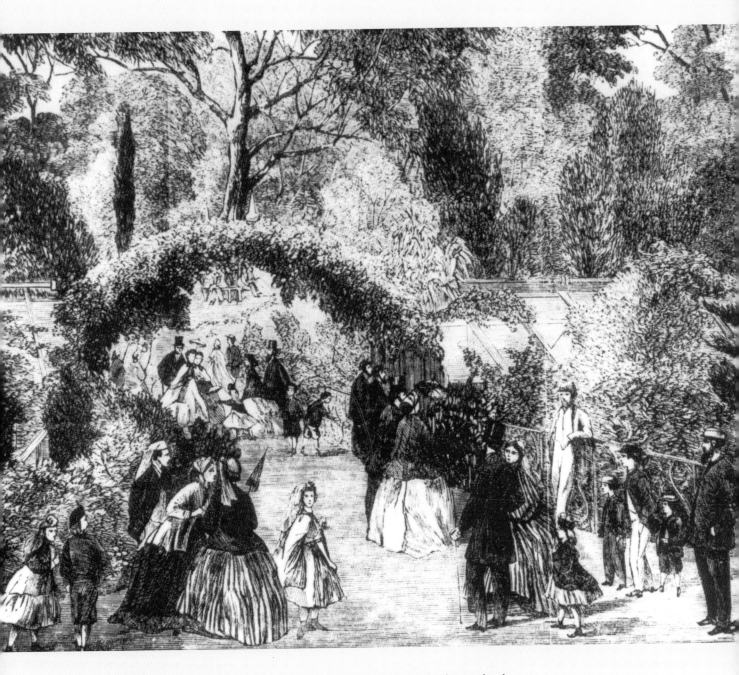

In 1857 a walk-through aviary was built in the Gardens, where English songbirds were bred then released throughout the Melbourne area. This drawing shows visitors at the entrance to the aviary in 1867. (Library, RBGM.)

grew from one to 1.7 metres in diameter. Later, beautiful rose and pink blossoms opened out, each of which lasted for about a week. An international contest had been held to see who could first induce this South American rarity to flower outside its native jungle; Mueller's aim was to be the first to persuade it to flower in Australia. His achievement gained him much public praise and attracted many more visitors to the Gardens. It was 1996 before the water lily was induced to flower again.

Another later project was the establishment of a Pinetum. In 1871 Mueller declared: 'A Pinetum will be reared, the locality, as a sheltered one, being not only favoured for the growth of the more tender pines, but also for an advantageous display of their noble forms.' Now known as the Hopetoun Lawn and Huntingfield Lawn, this area facing the western part of the lagoon was hard to landscape. Mueller planted it with native trees, which made way for lines of Aleppo Pine, Norfolk Island Pine, Morton Bay Araucarias and other rare conifers.

With all of these responsibilities, Mueller still managed to build what would become one of the leading herbaria in the world. Because of his superb contacts with botanists around the world, seed and plant donations increased. Mueller eventually built up a world-class collection of plant specimens for the Herbarium and the Gardens. In 1860, for example, he distributed 11 976 dried

plants to academic institutions and 20 438 plants, 2406 cuttings and 44 572 packets of seeds either to public gardens and reserves as reciprocal gifts to donors or as exchanges with Botanic Gardens overseas.

In a Director's report of June 1862, Mueller wrote that 'the interchange with kindred institutions continues.

During the month living plants arrived from Sydney, Adelaide, Launceston and Calcutta; seeds arrived in large quantities from Paris, Marseilles, etc.' He meticulously recorded and acknowledged the vast flow of contributions. From 1859 to 1867, inquiries for plants increased such that 355 218 plants were distributed to public reserves, cemeteries, church and school grounds in Victoria.

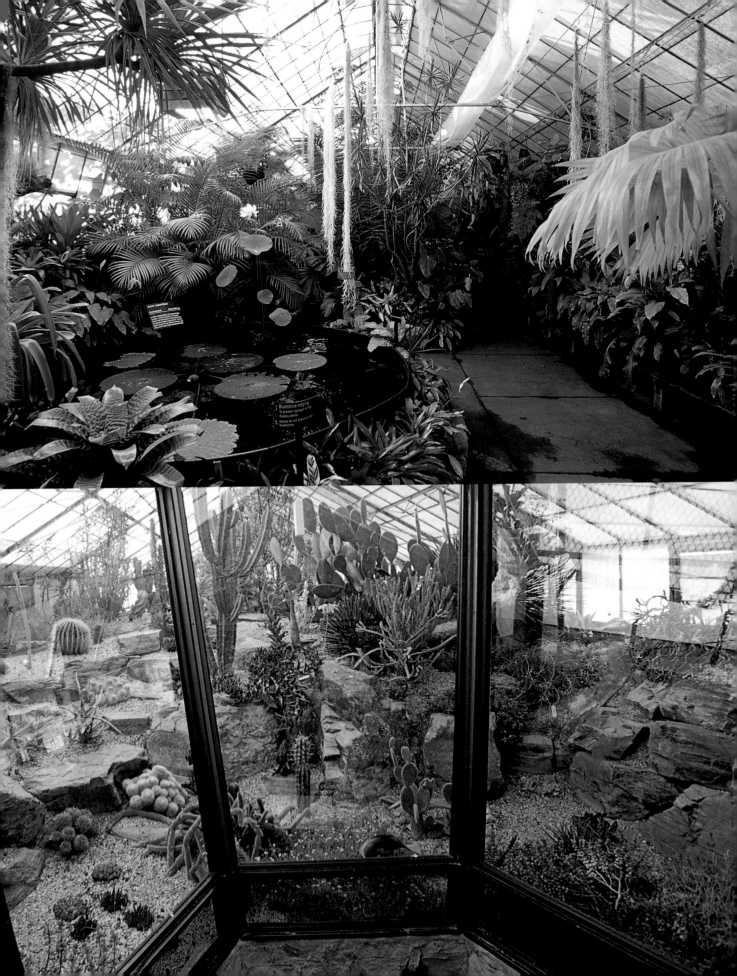

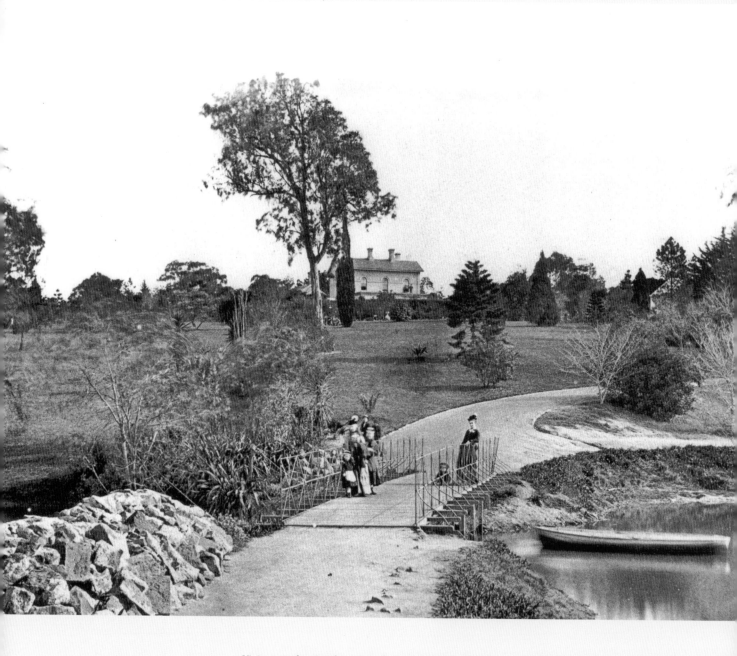

Visitors to the Gardens are photographed on Mueller's iron bridge, while someone looks on from the balcony of the Director's residence on the hill behind, 1875. (Library, RBGM.)

Eventually, however, the emphasis Mueller placed on seed distribution began to anger nursery owners, who felt that they were losing business. Their anger and the political pressure they exerted became one of the reasons behind Mueller's eventual downfall.

In May 1862 the minister responsible for Mueller, Chief Secretary John O'Shannassy, was presented with a petition signed by 40 members of the nursery and horticultural trades in Victoria. They complained about the Director's system of seed distribution, saying that it was 'very injurious to the interests of a most important trade and in consequence to the progression and development of Horticulture in this Colony'. They also believed Mueller's practice of seed distribution was a misappropriation of the Garden's funds.

The petition was acted upon immediately, with a set of regulations drawn up by Mueller under instructions from O'Shannassy that curtailed the distribution of seeds to private persons.

But this was just the beginning of the opposition to Mueller which grew over the next decade. The Victorian horticultural community at this time was essentially British in its outlook, and its membership. They weren't particularly interested in indigenous plants; in 1862, the Victorian Gardeners Mutual Improvement Society had passed a resolution that all public parks should be planted in the 'British style'. British style meant lots of lawns, plenty of trees for shade and masses of attractive flowers. Anonymous letters were published in newspapers, complaining about the state of the Botanic Gardens – not enough flowers, too many trees. These complaints were really about Mueller.

Eventually, pressure from those with vested interests and the newspapers helped pushed the government into setting up a Board of Inquiry to review the Gardens' management. Towards the end of 1871 the Board presented its findings to the Governor-in-Council. While Mueller's reputation as a scientist and explorer was never questioned, the Board felt that he had taken too much of a scientific and academic approach to the Gardens. William Ferguson, the Inspector of Forests and former gardener, was appointed temporarily as overall superintendent, with Mueller left nominally in charge. In reality, he was divested of his powers.

After two years of bickering, fighting and backbiting, a worn-down Mueller was told that his position at the Gardens had been made redundant and he was to leave immediately. The news devastated him – he was extremely embittered and reportedly never set foot in the Gardens again. However, he continued with botanical exploration in Australia and retained the post of Government Botanist until his death 23 years later.

In his years as Director of the Botanic Gardens Mueller had created a space that was famous throughout the world. He had seen to the planting of 30 000 trees, created a magnificent library from his own nucleus of over 1000 botanical books, laid out almost 25 miles of walks, protected the Gardens against devastating floods and droughts, set up the Herbarium and a laboratory (again based on his collection of 350 000 specimens) and distributed over 500 000 plants throughout the colony. Not only that, he had proved himself to be an intrepid explorer, an important writer in the field of botany, an outstanding researcher and a superb taxonomist, all of which had made him the most internationally decorated and honoured man in the country.

Left: Canna lilies.

Above: A black swan cruises the shallows of Ornamental Lake.

PEOPLE OF THE GARDENS
Sarah Theresa Brooks

Sarah Theresa Brooks was a member of the great network of collectors established around Australia in the late 1800s by the Government Botanist of Victoria, Baron Ferdinand von Mueller.

Born on the boat taking her parents and her older brother, John, to Australia in 1850, Brooks' life epitomised that of many of our European pioneers – one that was full of hardship in the pursuit of a better life. After arriving in Melbourne, the family settled in Geelong, only to have Brooks' father contract typhoid and die at 24 years of age.

Undaunted, Mrs Brooks opened a day school in Geelong and it was here that Sarah started her formal education, while her brother attended Geelong Grammar School. She also attended drawing lessons with Edmund Sasse, the art master at Geelong Grammar School.

After moving to Western Australia in 1873, the family settled first at Esperance Bay, then later, in 1877, at Israelite Bay. Sarah was a popular figure there. She painted landscapes, played the piano and sang, and was reputed to have been fluent in seven languages. She also received several marriage proposals and refused them all.

In 1883, Brooks happened upon an offer in the *West Australian*, an appeal by Mueller to settlers in outlying districts to assist in his botanical researches. He begged the newspaper to:

> urge inland and northern and far eastern settlers to induce the natives to bring, in baskets, specimens of all sorts of plants, to be dried at the stations and forwarded to me by post ... The minutest annuals should not be overlooked on such occasions. Perhaps I may not live many years to carry on my

investigations and I should like so much to give the finishing stroke for the elaboration of the rich and varied flora of Western Australia before I pass away.

Although he was Government Botanist for Victoria, his true field of endeavour was the whole of Australia. He made extensive trips himself, but relied heavily on collectors to be his eyes and hands in remote areas.

As the advertisement was timed to coincide with the start of spring flowering, Brooks was able to begin collecting immediately and, on 5 November, she had enough specimens to send a batch to Mueller. This was the beginning of a long and regular correspondence between Mueller and Brooks.

She collected plants including algae and fungi in the region of Israelite Bay and Russell Range (Mount Ragged) of far southeast Western Australia. The value Mueller placed on Brooks' work is in part revealed by the fact that he named two plants for her. The first was *Scaevola brooksiana* 'F. Muell.' that Brooks discovered in the vicinity of Israelite Bay. The second was *Hakea brooksiana* 'F. Muell.' which she found at or towards Mount Ragged. Mueller sent Brooks' algae collections to the famous Swedish phycologist J. G. Agardh, who named *Rhodophyllis brooksiana* 'J. Agardh' in her honour.

In 1886, Brooks joined her brother on an exploratory expedition, setting out from Israelite Bay towards a peak in the Hampton Range known locally as 'The Cliffs'. From here they headed to Mount

Ragged, which the local Aborigines reportedly had never climbed, for fear of being struck down by invisible spirits. From Mount Ragged, brother and sister travelled to Pine Hill, then eastward through eucalypt woodland to Balbinia, and north through increasingly arid country, finally ending up in the flat saltbush country broken up with only occasional specimens of *Pittosporum phylliraeoides*.

Like many of Mueller's collectors, Brooks appears to have ceased collecting plants after his death in 1896. She continued to express her interest in plants into old age and in a record of her impressions on a trip to Perth in 1927, published in the *Sunday Times*, she observed:

Coming back to civilisation after 50 years I was frequently asked what struck me most and I always replied, the beauty of the flowers. We first met them along the railway as we approached Perth the lovely blue lace flowers and the gorgeous orange plumes of the Christmas trees.

Brooks suffered a stroke in 1928 and was hospitalised in Norseman. She died on 23 September 1928, aged 78, and was buried in the Norseman Cemetery. In 1974 a Memorial Tablet was placed on her grave by the Royal Western Australian Historical Society and the Norseman Historical and Geological Museum.

A detail from a lithogram in Mueller's Eucalyptographia. *This* Eucalyptus amygdalina *is described in the book as '. . . one of the most remarkable and important of all plants in the whole of creation! Viewed in its marvellous height when standing forth in its fullest development on the slopes or within the glens of mountain-forests, it represents probably the tallest of all trees of the globe.' (Library, RBGM.)*

WILLIAM GUILFOYLE

The Master Landscaper

CHAPTER FOUR

THE REMOVAL OF Baron Ferdinand von Mueller had been difficult, so the task of finding his replacement was handled with caution. In the interim, the Minister for Lands, J. J. Casey, called for competitive designs to beautify the south side of the Yarra River and the whole park area, which included the Domain and Government House. Mueller had intended to continue to plant these areas, but the government had overruled this.

None of the twenty or so plans received in the competition was deemed quite right by the Minister until Caulfield resident and justice of the peace, Joseph Sayce, offered his as a gift. His plan comprised a pattern of wide curved paths, a large landscaped lake with islands and promontories, several extensive lawns, a fern gully and a series of summerhouses. This was considered greatly superior to the others and so he was commissioned to begin work. But difficulties began when Mr Sayce wanted a salary – the plans were a gift, but his labour wasn't. Suffice to say that these temporary arrangements weren't working out. It was time to appoint a new Director.

The Board of Inquiry, set up in 1871 to examine the work done by Mueller, had suggested that his replacement be 'a man of large experience and of cultivated and refined taste' and that 'the Government avail itself of the judgement of competent persons in the United Kingdom to obtain from thence a gentleman having the above qualifications'. But, not for the first time, the suggestion to look to the mother country for a new official was overlooked.

On 21 July 1873, William Robert Guilfoyle was appointed the Curator of the Botanic Gardens, Government House Grounds and the Domain. It was a temporary position, which kept Guilfoyle on probation for the next three years.

Guilfoyle's appointment was surprisingly adventurous. Although some might have seen it as nepotism (Guilfoyle was a relative of Casey), the appointment was as far-sighted and inspired as that of La Trobe and Mueller. Of this triumvirate, it is Guilfoyle who left the most permanent stamp of his tenure at the Gardens.

William Guilfoyle was born into horticulture. From Irish descent, he was the first-born son of one of England's leading nurserymen and landscape gardeners,

Michael Guilfoyle. Michael was an accomplished horticulturist – a 'gentleman's gardener' – and very interested in botany. Many Guilfoyles had been responsible for laying out and designing large estates in Ireland and England. And this inheritance wasn't confined to William's paternal side. His mother, Charlotte Delafosse, was a descendent of a French émigré family whose forebears included Count Louis Delafosse, an advisor to Louis XIV on his scenic gardens.

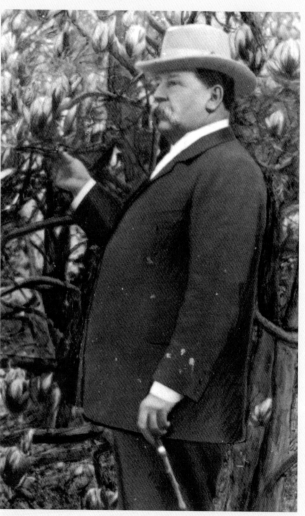

Michael and Charlotte migrated to Sydney with their family in the late 1840s, where he immediately established a nursery in Redfern. He was forced to close it down almost as quickly – the Gold Rush of the early 1850s meant that there was a lack of suitable labour and support from the public. Although he turned to designing and laying out properties of various wealthy Sydneysiders, he soon opened another nursery in Double Bay. Probably because of its more accessible location, it became an immediate success.

Constantly in demand for his 'English-style' designs, Michael Guilfoyle was responsible for designing and laying out hundreds of gardens around Sydney and in the nearer country areas. William had the opportunity of observing and probably taking part in the landscaping of these areas.

The 'English style' of landscaping that William observed was really a rendition of the eighteenth-century landscape influences of Alexander Pope, Lancelot 'Capability' Brown and William Kent, among others, which captured the intellectual heart of eighteenth-century garden design theory: landscape painting and the appreciation of nature. Called 'Picturesque', the style drew on nature as the ideal that gardeners should emulate. In the century that followed, gardens were designed along 'wild', 'rock' and 'woodland' themes, to accommodate plants, notably rhododendrons, from far-flung lands. Picturesque designs always balanced lawns with gardens and included plenty of vistas, both short and long. These vistas were effected by gently curved paths, which created a feeling of ease and anticipation of other features around each bend. Carefully positioned groups of plants, with central large shrubs or small trees, produced a landscape in which only a small portion was visible at any one time, while using dominant dark-foliaged trees – mainly conifers – on the skyline created a vegetation contrast with the lower, more varied foliage and floral display. Water was always a central feature.

In the early nineteenth century, landscape theory turned towards the concept of the 'Gardenesque'. The term, coined by John Claudius Loudon in 1832, married art and science, promoting a mode of garden design where plants

"Remodelling a garden is by no means an easy task. The formation of an entirely new one would be far less difficult."

– especially trees – could grow to their full height and display all of their characteristics without giving up a picturesque effect. The style promoted the use of foreign plants as a further means of distinguishing art from nature.

Michael Guilfoyle's gardens held influences from both styles and young William would certainly have gained his understanding of them from his father's designs, as well as through his own readings.

Even as a young boy, William had always displayed a special interest in and aptitude for botany and horticulture. Although he received little horticultural instruction from his father, he did receive a sound education from a number of sponsors, including his uncle, Louis Delafosse, who provided a private tutor to instruct him on English and European principles. He was later sent to Lyndhurst College in Glebe and then to a well-known private school in George Street.

The success of his father's nursery and his interest in natural history brought Guilfoyle in contact with the new colony's leading scientists and naturalists; in particular, the man behind the development of Sydney's Australian Museum, William S. Macleay, and naturalist John MacGillivray, who recognised his potential and helped him further with his tuition. They also encouraged him to undertake field excursions, at first around Sydney and then later to more remote areas on his own.

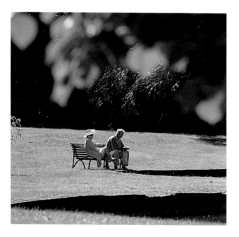
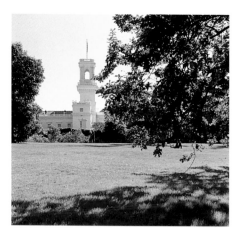

A late summer afternoon on Hopetoun Lawn.

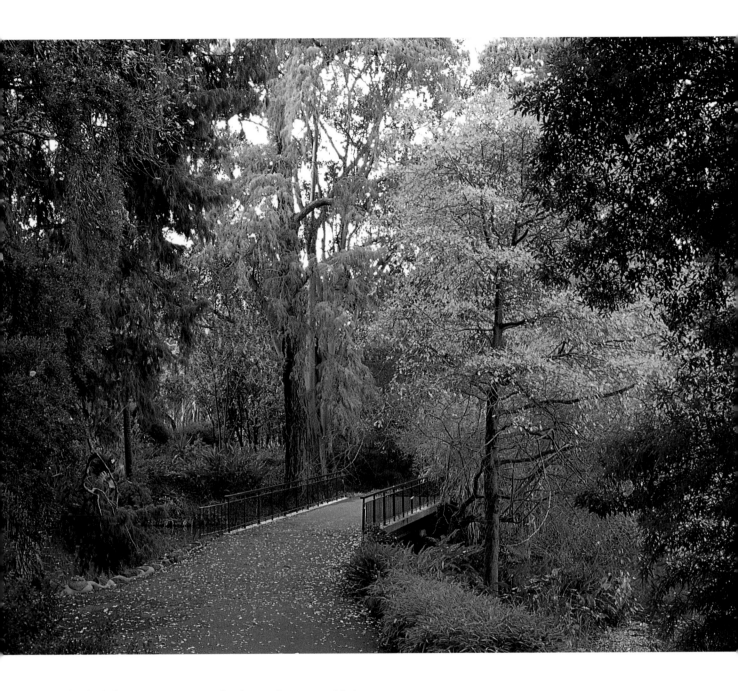

The bridge below Hopetoun Lawn, leading to Ornamental Lake.

William's father offered him a partnership in the business in 1862. The nursery's range of plants had increased to include bulbs, climbers and fruit trees – in all, more than 2500 different species and varieties were available. The Guilfoyles were said to be responsible for the introduction of the camellia and the jacaranda to Australia, which William later used extensively in his reorganisation of the Botanic Gardens in Melbourne.

In 1868 William accepted an invitation to join a British warship, HMS *Challenger*, on one of its routine trips through the South Sea Islands. He collected live plants in Samoa, Tonga, Fiji, the New Hebrides and New Caledonia for his father's nursery and Sydney's Botanic Gardens. William became enthralled by the variations in shape and colour of these tropical plants and later tried to simulate the Islands' landscape in the Botanic Gardens in Melbourne. The plants would form a nucleus of the Melbourne Gardens' conservatory collections.

After his return in 1869, William joined his father at his property in Cudgen, near the Tweed River. He remained there until 1873, not only producing crops such as sugarcane, tobacco, corn, cotton, coffee, peanuts and opium, but also collecting live plants or herbarium specimens, many of which were forwarded to Mueller in Melbourne.

At the age of 33 William Guilfoyle was offered the position of Director at Melbourne's Botanic Gardens. Guilfoyle's first report to the Inspector-General of Gardens, Parks and Reserves was written eighteen days after his appointment and summarised the conditions of the Botanic Gardens and the Domain

William Guilfoyle's sketch of landscaping a lawn shows the philosophy for which he is perhaps best known: 'Nothing can excel the glimpses afforded by the openings between naturally formed clumps of trees and shrubs . . . At every step the visitor finds some new view – something fresh, lively, and striking.' (Library, RBGM.)

"In the summer of 1877 more than 1000 loads of silt were removed by wheelbarrow and used as top dressing for the recently established lawns."

Reserve as he found them. (The Domain had been permanently reserved within the Botanic Gardens' boundary in July that year.) His observations highlighted the differences between his concept of a botanic garden and his background in the English landscaping tradition, compared with that of Mueller. Although Mueller appreciated the aesthetic, he was a botanist first, while Guilfoyle was a horticulturist and a designer. He agreed with his predecessor on the scientific purpose of the Gardens, but he believed that it should be balanced by recreational and aesthetic designs.

Guilfoyle's fundamental objection to Mueller's vision is clear from his comment on the 'state of confusion in which I find this Garden'. First, he complained about the lack of lawns, which he considered essential in encouraging visitors. Second, he disagreed with Mueller's extensive planting of avenues with large trees and the large number of walks or paths. He strongly recommended that the plants of *Grevillea robusta*, Monterey Pine (*Pinus insignis*, now *P. radiata*), upright cypress and Bunya Bunya Pine (*Araucaria bidwillii*) be

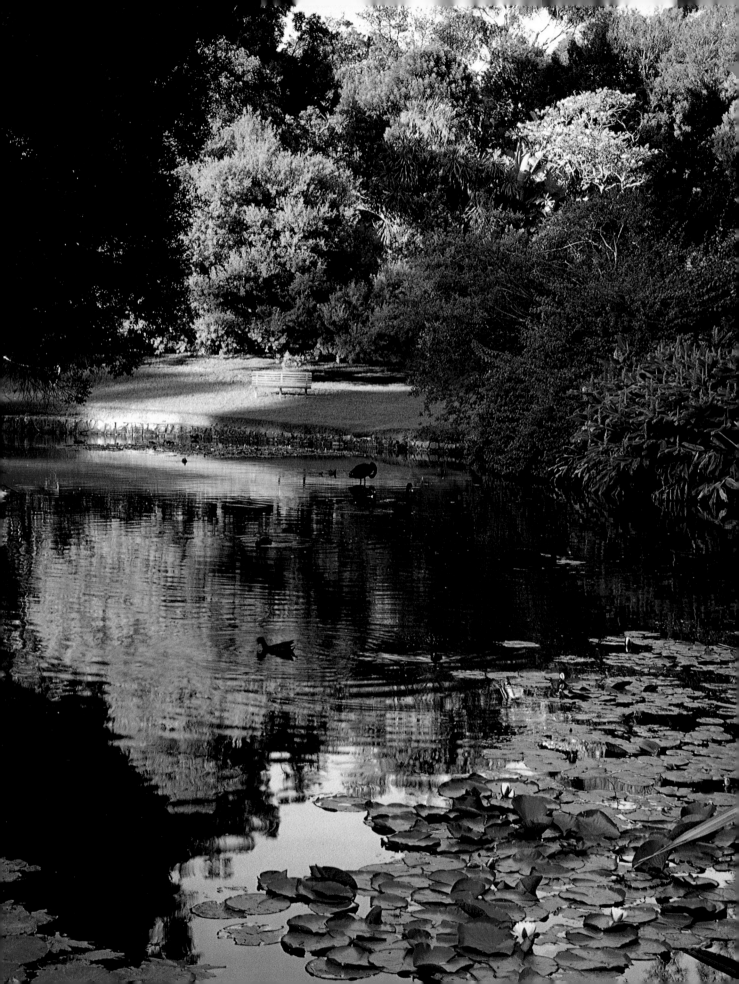

lifted from the Pinetum and planted throughout the Gardens – the first taste of the later move of thousands of established trees to more prominent sites. By 1874, Guilfoyle had already started 'to cut down a number of unsightly indigenous trees throughout the grounds', culling *Hakea*, *Eucalyptus*, *Acacia* and *Melaleuca* specimens, so that only the best remained.

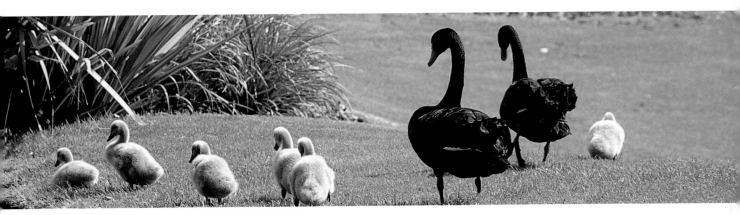

The vision for which he is now so well known was explained in that first report:

> One of the great essentials in landscape gardening is the variety of foliage and disposal of trees. Nothing can excel the glimpses afforded by the openings between naturally formed clumps of trees and shrubs, whose height and contrast of foliage have been studied. At every step the visitor finds some new view – something fresh, lively, and striking, especially when tastefully arranged. Where long sombre rows of trees are planted, and a sameness of foliage exists, the very reverse is the case. Nature's most favourable aspects then seem sacrificed to art, and that art often produces but a chilling effect.

Commenting that 'landscape beauty seems to have been sacrificed to correct geographical classification', Guilfoyle stated his intention to bring those plants which had been hidden by taller trees, such as *Gardenia*, *Myrtus*, *Justicia*, *Polygala*

Left and above:
Nymphaea Lily Lake.

and palms, into prominence. He also was struck by the absence of camellias, azaleas and rhododendrons (of which he had extensive knowledge from his father's nursery). These, he believed, should be included for their flowers and for their variations in foliage.

⊚ PEOPLE OF THE GARDENS
Percy St John

One of the most important services rendered by any Botanic Gardens is providing the public with the correct identification of plants. In 1917 this feature began to assume considerable importance. Some 700 specimens were named during this year and returned to inquirers. This work was carried out by Percy St John, who was appointed as 'boy assisting the seedsman' in July 1883, shortly after his eleventh birthday. St John was eventually promoted to the senior position of classifier. Besides the identification of specimens submitted to the Gardens, his work entailed giving advice on methods of cultivation and maintaining the herbarium collection in the Gardens. He also created a reference herbarium of the local flora that is still housed in the lodge on Mount Buffalo.

St John, who had regularly collected wild flowers as a young boy in the early 1880s for the 'benefit of the Baron', attributed his lifelong study of eucalypts to Mueller's personal encouragement. At the time of his retirement at 65, he had completed 54 years of service. He died in 1944, at the age of 72. ⊚

The report also advised that many of the garden borders would be dug and planted out with herbaceous plants, particularly annuals, which would produce a brilliant colourful effect.

Guilfoyle was very aware of what the public wanted and managed to work very quickly to establish his credentials. His initial designs modified Sayce's original plan, while later concepts reflected his background training and understanding of both the Picturesque and Gardenesque styles. Its principal features were spacious lawn 'affording a bright and elastic turf over which visitors

could roam at pleasure', rather than being confined to Mueller's paths and walks. 'Remodelling a Garden is by no means an easy task,' he wrote in 1876:

> It can easily be understood that the formation of an entirely new one, would be far less difficult ... the grounds [at the Melbourne Botanic Gardens] have great natural advantages – undulating surface, hills and dales, lakes in their centre, and fine views of Hobson's Bay and the ocean ... And while picturesque effect is created, the primary object of a Botanic Garden – namely; the proper botanical classification and distribution of plants – can be thoroughly carried out. Indeed, it is far better to group the various orders of plants, large and small, throughout the Gardens in such a manner, as to aid in producing a pleasant landscape (even in a botanical sense) than to huddle all the orders together ... The whole garden should be a system, so to speak, and the only order of plants so arranged as to prove not only picturesque, but instructive. Of course great care is necessary in pursuing this course, especially in representing the vegetation of the different zones. At every step the visitor should see something to remind him that he was in not only a Landscape, but also a Botanic Garden.

Guilfoyle had three methods to achieve the garden design he wanted. He transplanted trees to specific points where they would act as a framework to the design; he replaced narrow paths with broad sweeping walks that would allow lawns to be planted with groupings of plants; and he cleared and beautified the lagoon to make it the real focus of the Gardens. By the time he retired some 36 years after he became Director, not one vestige of Mueller's work would remain.

Perhaps the best example of what Guilfoyle's biographer R. T. M. Pescott calls his 'genius' was the transplanting of hundreds of large trees – usually conifers – so as to supply a suitable background for more extensive landscaping. It was common thinking in Guilfoyle's time that such large trees (some of them were more than 6 metres in height) couldn't be moved, and criticism of his plans was rife among Melbourne's horticulturalists. Guilfoyle, however, insisted that these

Overleaf: Early morning overlooking the Gardens from Government House.

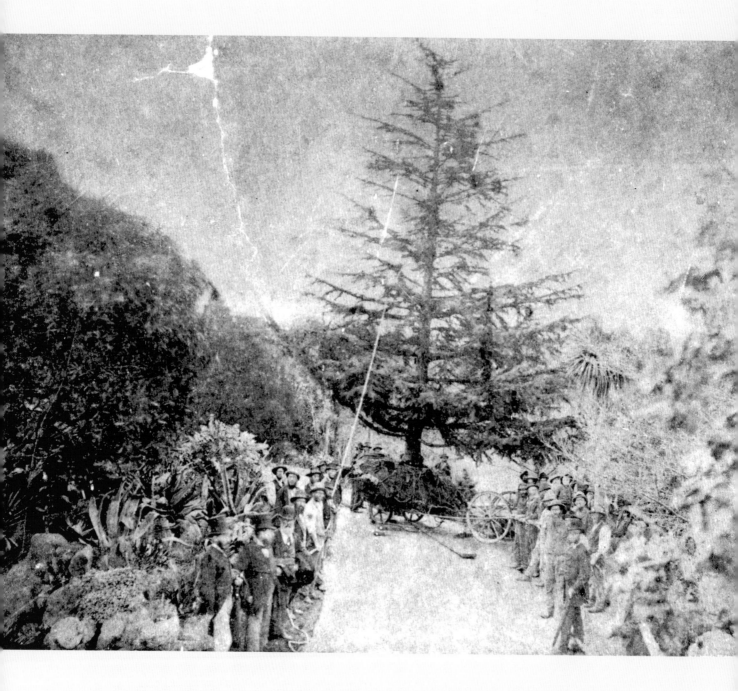

*William Guilfoyle organised the transplanting of hundreds of trees in the mid 1870s.
Here, a large cedar is moved by two-wheel dray and horse from the area where
the Temple of the Winds now stands. (Library, RBGM.)*

trees could be moved, even in supposedly unfavourable conditions. In fact, moving well-grown plants was unavoidable 'where it is necessary to produce a landscape effect within a limited time', he wrote in his first annual report.

The first trees were moved into new positions in December 1873, and were 'all doing well', as the foreman noted (at Guilfoyle's insistence) in the 1873–74 Annual Report. 'In no other Colony has such an undertaking been carried out to this extent, and the attendant success proved the geniality of the climate for this sort of work,' the Director wrote with some pride in the same report. In the six months to March 1875 – a season 'generally considered unfavourable for this sort of work' – 832 large trees were transplanted, with the aid of a two-wheel dray, two horses and manpower. These were all between 8.5 and 10 metres tall and included such trees as the Norfolk Island Pine (*Araucaria heterophylla*), Bunya Bunya *(A. bidwillii)*, *Cupressus* and *Brachychiton acerifolium*. Only six trees were lost.

Guilfoyle considered lawns and plants to be of equal importance. To give the Gardens a 'bright and elastic turf', it was necessary to replace more than 3200 metres of formal and narrow walks with grass. Guilfoyle used Buffalo and Doub grasses, as well as English varieties, and found that 'a judicious mixture of these produces a more elastic, permanently vivid and beautiful turf than any single species of grass'. Turf also required much less maintenance than paths; the lawn that covered more than 3200 metres required only a mower pulled by one horse and attended by only one man to maintain. Once the lawns were established, they would be enhanced with trees and other plants, as he had stated in his Annual Report of 1874: 'I also have in view the opening up of diversified scenery by the formation of picturesque groups and clumps of trees on the lawns, the glimpses through which will altogether change the appearance of the gardens.'

The first extensive area to be developed was the Buffalo Lawn, now called the Princes Lawn, about a hectare of land that swept down to the lagoon from the Director's House. Guilfoyle planted the lawn with beds of brilliant flowers and sub-tropical plants, such as many of the transplanted palms. He also brought in bamboo, Pampas Grass (*Cortaderia selloana*), *Arundo, Yucca* and *Dracaeana*.

Guilfoyle's determination to make the lagoon the focal point of the Gardens was following the Picturesque tradition, which always included a water feature, even if an artificially produced one. His aim was for the lagoon 'to take its proper place as one of the salient points in the landscape; and when the remodelling of the Gardens is complete, [it] will provide a most important and attractive feature in the views to be obtained from various points'. It was an aim that was to require a great deal of work.

The lagoon was shallow, with one large and several small islands on which native plants, mainly melaleucas, flourished, and parts of it were swampy and covered in rushes. Guilfoyle decided to deepen the main part of the lagoon and to raise the large island by as much as $2^1/_2$ feet and replant it. Work began in the driest part of summer, when the water levels were at their lowest. This meant that the accumulated silt and humus from the lagoon bottom could be used throughout the Gardens and help raise the level of the low ground at the lagoon's head.

In the summer of 1877 more than 1000 loads of silt were removed by wheelbarrow and used as top dressing for the recently established lawns. (Removing silt from the Ornamental Lake continues irregularly to this day, to maintain a regular depth of water in the lagoon, although machines have since replaced wheelbarrows.)

The island's Pampas Grass was replaced with a combination of shrubs, including the Western Australian Scarlet Flowering Gum (*Corymbia ficifolia*) which Guilfoyle had been impressed by, as well as rhododendrons, *Magnolia grandiflora* and jacaranda. These, he felt, would 'introduce the warmth of colouring so necessary to the finish of a perfect picture'.

Work on the lagoon was given a boost in 1896 with the passing of the *Yarra Improvement Act*, designed to stop the river flooding by straightening it. Besides adding another 1.5 hectares of land to the northern front of the Gardens, the river's new path also provided a broad link between the east and west sections. And it subsequently isolated the lagoon from the river, making it self-contained, and gave us Alexandra Avenue; the lagoon's water was now supplied by the run-off of

Right: The northern banks of Ornamental Lake in late spring.

Overleaf: Midwinter sunshine on Southern Lawn.

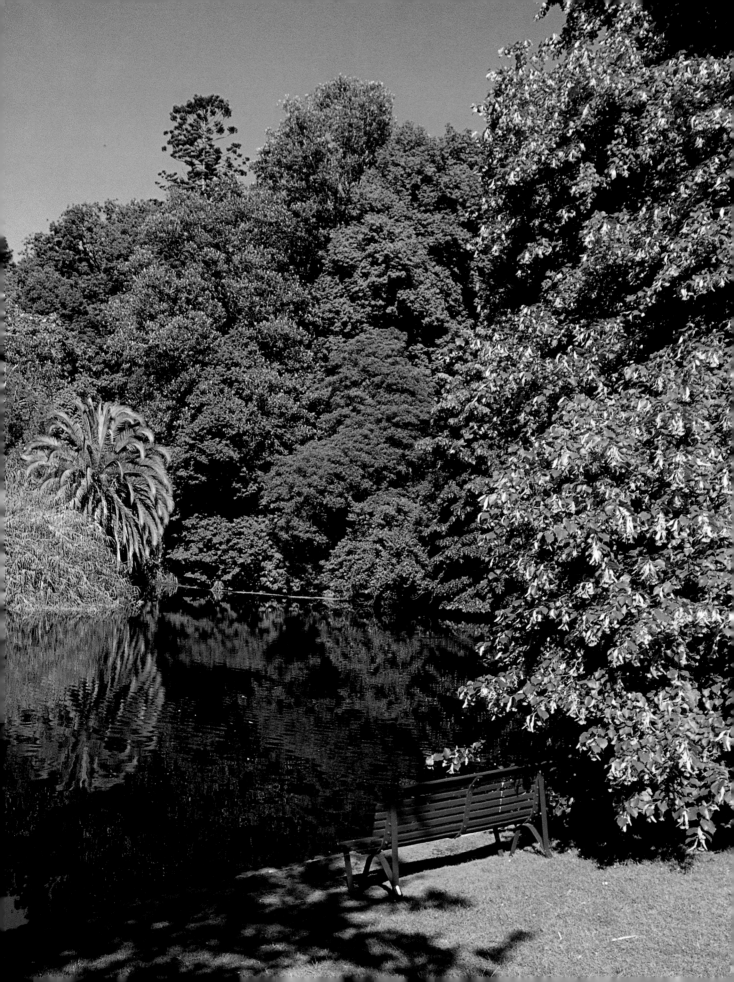

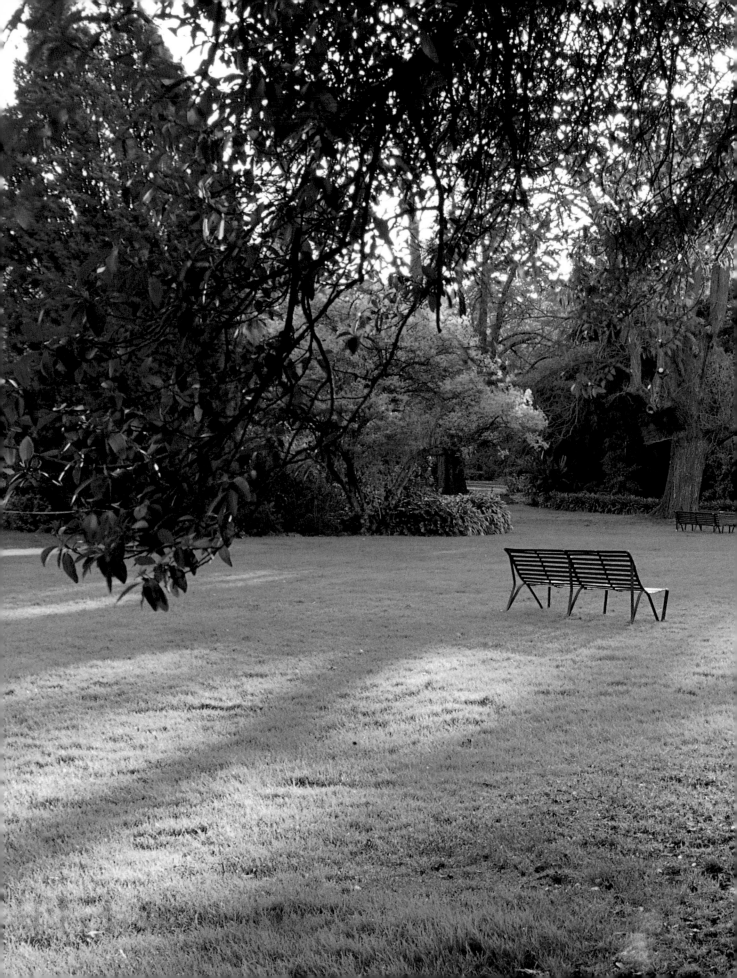

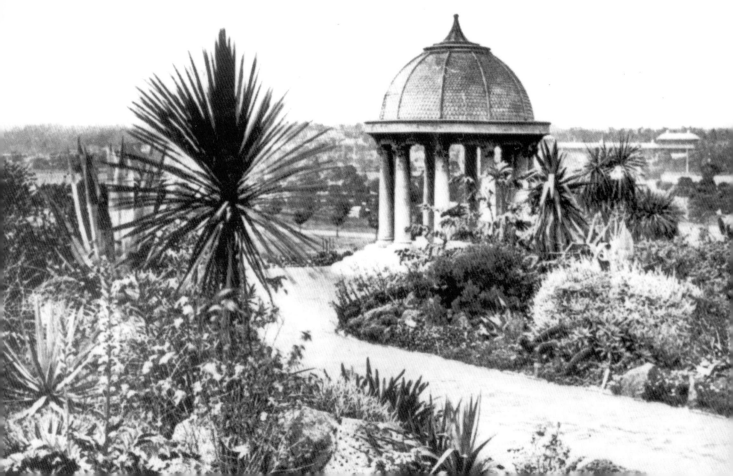

rainwater from surrounding areas. Free from the worries of flooding, Guilfoyle could make the lagoon the visual centre of the Gardens, as he had imagined.

Taking advantage of the extra land (apart from the land gained by straightening the river, another 1.2 hectares had been added to the 18-hectare garden in 1875, with the acquisition of a cow paddock from the Government House grounds), Guilfoyle began construction of the Temple of the Winds, which would be dedicated to Charles La Trobe. It was positioned on top of a hill overlooking a new thoroughfare formed after the straightening of the river.

Designed and built by Guilfoyle and his staff in 1901, the Temple of the Winds reflected the classic architecture that the Director had seen in his travels to Europe in the late 1880s. With its ten columns (instead of the more usual eight or twelve) and topped by staghorn ferns, rather than the generally accepted Corinthian capital leaf, acanthus, in a way it typified Guilfoyle's approach to design: it may look traditional, but there is always a unique twist.

Other buildings were erected, including a rustic tea house which replaced the old propagating house that had stood on the southeast bank of the lagoon almost since the Gardens' first days. The tea house remained opened until it was destroyed by fire in 1970.

From 1900, Guilfoyle's health began to deteriorate to the point where he was forced to direct operations from a wheelchair. He retired in September 1909, and died at 'Chatsworth', his home in Jolimont, in 1912.

Guilfoyle knew that he would never live to see his reconstructed Gardens in their finished form – it took another 50 years for them to reach maturity, partly because lack of funds and labour during the two world wars resulted in extensive deterioration. Successive Directors have modified his plans, changes have been made to plantings and new gardens added. The bright beds of annuals have largely given way to perennial shrubs and smaller plants. But the trees are still planted as single specimens, rather than in groups or rows, so as to allow them to take their natural shape in the landscape, and Guilfoyle's aims of achieving subtleties of foliage and colour are as paramount as ever.

Previous page: Framed by a Norfolk Island Hibiscus (Langunaria patersonii), *Tennyson Lawn absorbs the last rays of winter sun.*

Top left: William Guilfoyle c.1903 at the entrance to the medicinal garden. (Library, RBGM.)

Bottom left: The Temple of the Winds, constructed in 1901 under the directorship of Guilfoyle, was dedicated to Charles La Trobe who was enormously influential in setting up and developing Melbourne's Botanic Gardens. (Library, RBGM.)

A PARK FOR
THE PEOPLE

THE BOTANIC GARDENS HAS ALWAYS held a special place in the hearts of Melburnians. From the first, Superintendent La Trobe perceived it as a place of retreat for the people – a calm, peaceful and attractive oasis in the midst of the new town's mud and dust and ebullient commerce. From the moment the Gardens opened, the townspeople flocked there to meet friends and family, to look at and admire the flowers and plantings, to promenade around its walks or by the edge of the lagoon, to listen to music and to dance at midnight balls. Entry then, as now, was free of charge. It became a venue not only for social and recreational gatherings but also for public celebrations and charity functions.

The first official social functions were the Government House garden parties, held by La Trobe during John Arthur's tenure. In 1850, contemporary diarist and family friend of the La Trobes, Georgiana McCrae, recorded that, after the opening of the new Princes Bridge, she and the Governor's children went to the Botanic Gardens, where they shared in the distribution of 2000 buns to the township's youngsters.

The Gardens really came into its own in the celebrations to mark the birth of the Colony of Victoria. For several years before 1850, Melbourne's citizens had been agitating for a separation of the Port Phillip District from New South Wales. This was seen as essential if the settlement was to progress. After several attempts at gaining agreement on this issue with New South Wales, La Trobe sent a petition to London, seeking approval. To the great delight of the petitioners representing the general population, it received Queen Victoria's approval. Effective from 1 July 1851, the new state was to have the name Victoria, in her honour.

In the ensuing celebrations, refreshments were again served to all of the town's children, on the newly developed lawns immediately to the east of the old, large River Red Gum (*Eucalyptus camaldulensis*) close to Anderson Street. The tree later became known as the Separation Tree and exists to this day. La Trobe also planted a specimen tree of the English elm, *Ulmus procera*, a little to the west of the Separation Tree, a year later, which was closer to the time of the

"Now, all that was required for this event to be a great success was good weather but, Melbourne being Melbourne, the newspaper reported that a 'hurricane' blew in from the southwest, destroying most of the decorations."

actual separation. This tree remained until 1977 when, because of rotting at the roots, it fell and died. Several young plants were propagated from the fallen tree, one of which was replanted in the original site in 1979 by Dr John Henry de la Trobe of Hamburg, Germany, a descendant of Charles Joseph La Trobe.

The first charitable event to be held in the new Botanic Gardens was described by the *Argus* as a 'splendid musical treat' for the benefit of the Melbourne Hospital in 1853. To be held on the first two days of March, the concert was advertised in the newspaper as having a vast array of talent unique to the colony, which would include vocalists, instrumental performers, a horn

band and the very popular military band of the 40th Regiment. Now, all that was required for this event to be a great success was good weather, but Melbourne being Melbourne, the newspaper reported that a 'hurricane' blew in from the southwest, destroying most of the decorations. Consequently, the musical treat was postponed for a week. This time, the weather held out and it was most successful, with 2000 people visiting the Gardens each day and contributing over £400 towards the hospital. Reporting on the festivities on 9 March 1853, the *Argus* commented on the Garden's excellent order: 'the rare and beautiful plants in full flower very greatly enhanced the pleasure of the scene'. The article made much of the fact that there wasn't any drunkenness and that many visitors refrained from smoking tobacco.

Perhaps it wasn't surprising that the crowds behaved in an orderly, middle-class fashion, as the Gardens appealed more to this class than the more boisterous diggers and their courtesans. Superintendent La Trobe stamped a special cachet on the Gardens when he instigated his garden parties, and his attendance at the Band of the 40th Regiment's weekend concerts at the Gardens helped attract more genteel Melburnians. Its proximity to the town's wealthier suburbs meant that the Gardens naturally drew in its middle-class neighbours, who defined its social uses.

The Gardens soon became the site of Melbourne society's rituals. The band concerts gave the citizens a chance to see and be seen; the number of visitors to the Gardens kept increasing substantially every year. During 1850 and 1851, for example, the average attendance on a Sunday had reached around 800 people, fewer during the week. By 1857, it was Melbourne's 'favourite place of promenade' and was seen as one of the colony's principal institutions.

People visited for many reasons. The Victorian era's interest in botany and horticulture ensured many visitors, and the birdlife attracted others. Early sketches reveal the presence of numerous indigenous waterfowl on the lagoon, which were a source of constant interest because they were so different from the waterbirds of England and Europe. The arrival of four white swans on the ship *Medway* from England early in March 1853 was seen as attempt to alleviate

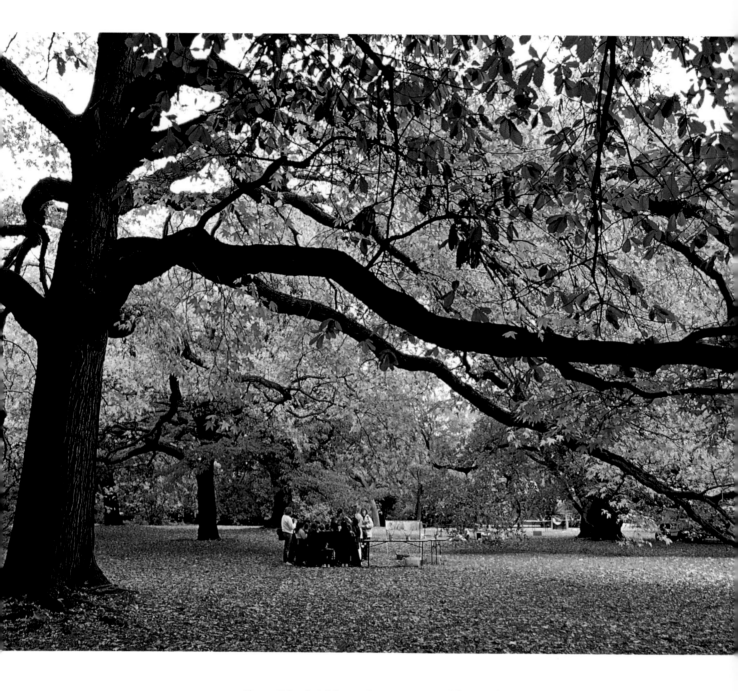

Above: School children take part in one of the Gardens' education programmes, under the enormous branches of a liquidambar (Liquidambar styraciflua) *on Oak Lawn.*

Right, top: The snack bar and tea rooms beside Ornamental Lake.

Right, bottom: A summer morning on the tea rooms' boardwalk.

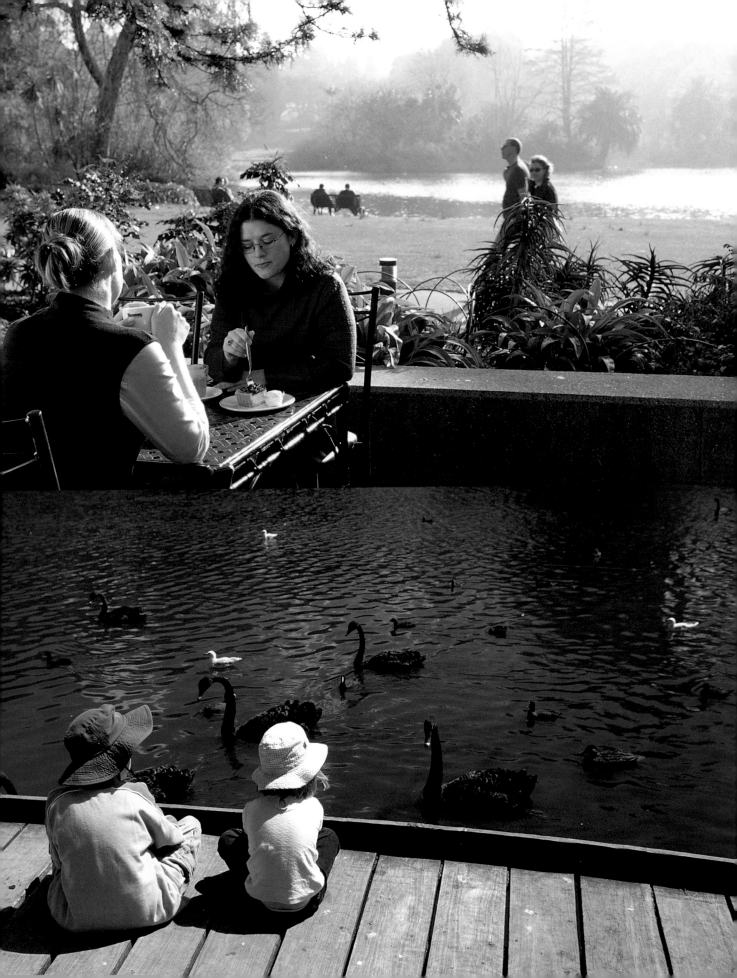

nostalgia; unfortunately, they fell victim almost immediately to the sporting interests of the non-nostalgic types. They were killed by dogs belonging to shooters, who, said the *Argus*, 'in defiance of the law, shoot in the police paddock' adjacent to the Gardens.

The intense interest in horticultural matters led one of the city's founders, John Pascoe Fawkner, to suggest that a horticultural society would be a valuable addition to the community. Fawkner placed a notice in the *Argus* in 1848, asking those interested to attend a meeting, and the Horticultural Society was subsequently formed. Although the Society only lasted until 1854, it had success with several exhibitions and flower shows held in the Botanic Gardens, which attracted up to 700 visitors. A crowd of 2500 people and their vehicles attended the Society's Flower Show in 1852, including the Governor, the mayor and other influential citizens.

The appointment of a Government Botanist in 1853 saw another resurgence of interest in the Gardens from both the planning committee and the general public. Ferdinand von Mueller brought to this newly created position a thoroughness of scientific approach and practical application that many had thought was missing. There had been complaints that, although Curator Dallachy was doing a fine job, he was concentrating too much on the aesthetic side: few plants were named and the Gardens' educational role was being neglected. Mueller, on the other hand, was already making a name for himself for his discovery and classification of new species.

By 1855, the number of visitors had increased to the point that it was necessary the Gardens' opening and closing hours be listed in the newspapers. A journalist from the newspaper *Newsletter of Australasia* wrote in 1858:

> The Melbourne Botanic Gardens are every day acquiring additional importance as a favourite place of public promenade, while the admirable manner in which they are managed, and the intelligent care bestowed upon the arrangement and in the cultivation of the plants, have effectively recommended the design for which the Gardens were originally instituted. Dr Mueller has a most competent aide in the person of Mr Dallachy, and it is to

the co-operation of these two gentlemen that the citizens are indebted for the very beautiful appearance which the Gardens now manifest ... one of the principal public institutions of the Colony.

With the increase of visitors came the need to provide better access. It was proposed that the Gardens' boundary lines be extended and new entrances be added to accommodate the growing number of local residents who walked through the grounds to and from work each day. Other propositions included the construction of convenient landing places for ferries on the side of the Gardens bounded by the Yarra and a gate in the centre of Government Park, a portion of which was in the process of being added to the Gardens.

The idea of a horticultural society was revived around this time, and the new Horticultural Society of Victoria was established in 1855, with Mueller as chairman. It was an immediate success and soon had a membership of nearly 400 people. Its first exhibition was held in the Botanic Gardens on 5 March 1857 and was reported to have been very successful. According to the *Victorian Agricultural and Horticultural Gazette* in 1857:

> The Show of flowers was not so extensive as some persons expected; but the number of visitors was so large, and the flowers, fruit and vegetables exhibited of so much interest and admiration that there can be no doubt, that before the next exhibition, our gardeners will see the desirability of competing for the Society's prizes, and that amateurs also will enter into generous rivalry.

A two-day spring exhibition was held in October the same year. The Governor, Sir Henry Barkly, was among the visitors and the event was reported in the Gardens' annual report to be 'numerously and fashionably attended' by Melbourne's community.

These exhibitions soon became regular events in Melbourne's social calendar. Housed in large marquees, with music provided by the Band of the 40th Regiment in a special bandstand, they were held on the Eastern Lawn in March, October and December for nearly 50 years.

By October 1858, Mueller estimated that around 200 000 people were

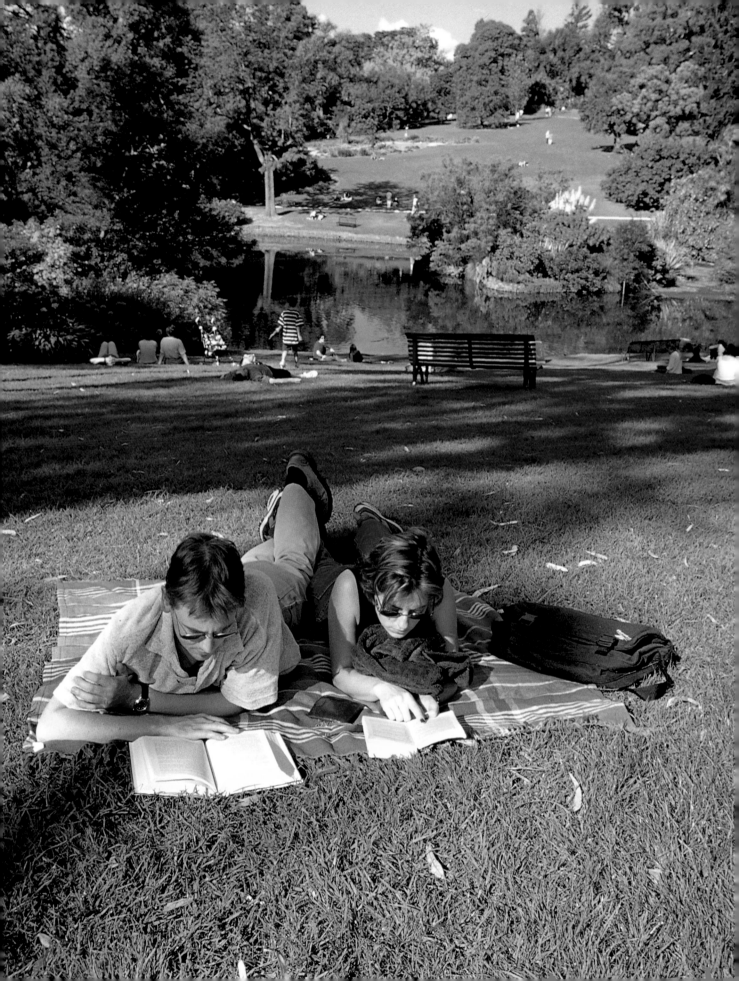

visiting the Gardens annually. The increases were probably due to the completion of the Yarra River footbridge, which enabled more direct contact between the residents of East Melbourne, Richmond and Collingwood and those from South Yarra and the immediate neighbouring areas. The newly opened Botanic Gardens Station, located in line with the footbridge over the railway lines near the Melbourne Cricket Ground, saw another increase in attendance figures – during a seven-month period in 1859, more than 41 000 people visited the Gardens. No longer could the Botanic Gardens be seen as the province of the middle and upper classes.

The Gardens also continued to be a venue for social functions. The Eight-Hours Fête was a special celebration in early 1867. The festival, held to celebrate the success of the Eight Hours Movement, was held on Easter Monday and more than 6000 people paid the admission fee of one shilling at the gates.

It was during Guilfoyle's term that the Botanic Gardens truly became a park for the people. One of the master landscaper's first tasks was to plant lawns for picnics and concerts, and as open spaces to set off plantings. Mueller's Pinetum was broken up to create immediate as well as far-reaching vistas, and a series of ornamental lakes was created from the reedy lagoon. Rustic shelters in the form of summer houses, or kiosks, as Guilfoyle preferred to call them, were dotted around the Gardens. Some of these were made from the wattles that lined the banks of the Yarra and each was built with wooden seating for up to 50 people. A proprietorial interest in all the changes was encouraged through notices placed around the Gardens, reminding visitors that 'these Gardens were established for the recreation and enjoyment of the people, and the improvements are placed under their guardianship'.

The public loved the Gardens' clever and unobtrusive mix of science, horticulture and floristry, exemplified in areas such as the summer season floral displays and the Fern Gully. The latter was Guilfoyle's earliest landscaping success. Guilfoyle had Mueller's aviary and the bridge where it straddled the

Left: Princes Lawn on a summer afternoon.

Inset: Linden tree leaves (Tilia cordata) *collect on an Asparagus Fern* (Asparagus setaceus).

creek dismantled to create an extensive natural fern glade. A path dipped into a hollow, which gave views into the gully and down to the islands in the lagoon. Another path encircled it and a rustic rest house, complete with a thatched roof, all helped make it a tourists' delight.

After-hours social functions, such as the moonlight concerts held to aid various charities, helped bring in the numbers. They were held on the Eastern Lawn, in the same area that Superintendent La Trobe had held his official garden parties 30 years earlier. According to the weekly newspaper the *Australian Sketcher* in 1875:

> Of all the entertainments offered in summer time to the pleasure seeking people of Melbourne, none offer more picturesque attractions than the concerts sometimes held about full moon in the Botanic Gardens. They are held in a delightful spot, where the rich foliage of the shrubs and trees and floral displays of the borders are touched and silvered by the mild radiance of the moon. Groups of brightly dressed promenaders stroll about the paths ... and the strains of the fine bands pervade all the sounds and the sights like a magnificent accompaniment ... it is not wondered at that these concerts are very popular.

During his 36 years as Director, Guilfoyle brought ceremony to the Gardens by encouraging visiting dignitaries and some locals to plant specimen trees, usually in the lawns – a practice begun by La Trobe with his separation tree which continues to this day. A stream of British princes and princesses, ladies, lords and governors of Victoria, as well as celebrities, such as Dame Nellie Melba and composer-pianist Ignace Paderewski, have wielded a shining shovel to make their mark in the Gardens. Many of the plants remain, including the Duke of York's Deodar cedar (*Cedrus deodara* 'Viridis', planted on 7 May 1901), Paderewski's Mountain Grey Gum (*Eucalyptus cypellocarpa*, 1904) and Australia's second Prime Minister Alfred Deakin's Jelly Palm (*Butia capitata*, 1908). In 1951, the Governor of Victoria planted a seedling River Red Gum (from the old Separation Tree), to commemorate the centenary of the

PEOPLE OF THE GARDENS
Tommy Rush

Tommy Rush was a propagator who worked at the Botanic Gardens from 1900 to 1945. In his early years there, he travelled with Gardens' Director, William Guilfoyle, on weekend expeditions to gather plants, some of which have survived as pressed specimens. His son Jack remembers Tommy talking about the Gardens.

'The first job that I can pin on [my father] was mowing the lawns … with the horse-drawn mower [Tommy Rush and another gardener are pictured below, in 1908]… then I think he became a gardener … He passed through years of service, and ended up as the propagator, in charge of the nursery. My father's section was the Nymphaea Lake. He was there all the time that I recall. Every gardener had his own section, except fellows that were in an overseeing capacity – Percy St John, for example, would have been a wanderer through the place.'

'My father often used to refer, with a great deal of pleasure, to the different Toorak families that would frequently stroll through the Gardens. The nursemaids and even the parents would always have a conversation with him. They would question him not only on gardening but on all sorts of cultural matters as well.'

'Due to enlistments, there were labour shortages, so members of the Gardens' staff undertook to make up by working on a Saturday afternoon. It was called Patriotic Saturday and I have a feeling it would have been once a fortnight, maybe once a month. I remember my father coming home from work on a Saturday at 5 o'clock. Mum used to say that Dad was working a Patriotic Saturday and he had no objections to that.'

'He used to say that he was given the opportunity to live in the Gardens, but he didn't like the idea. He said that it was too remote for the family. Motor cars weren't involved in the early days and tram services and that sort of thing were a bit remote, particularly for women at night time. Dad felt it was pretty hazardous.'

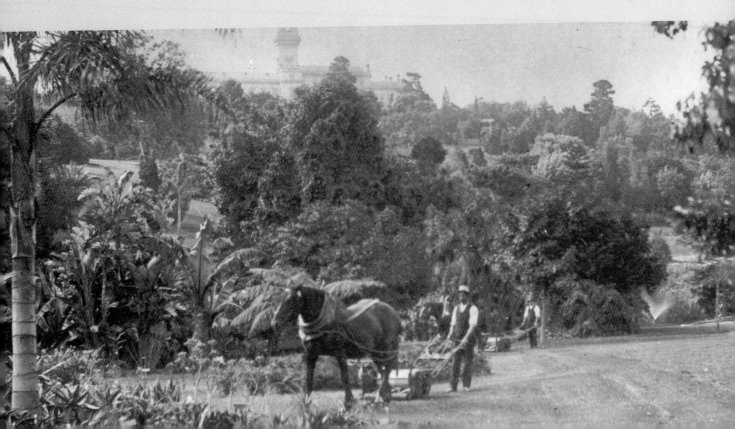

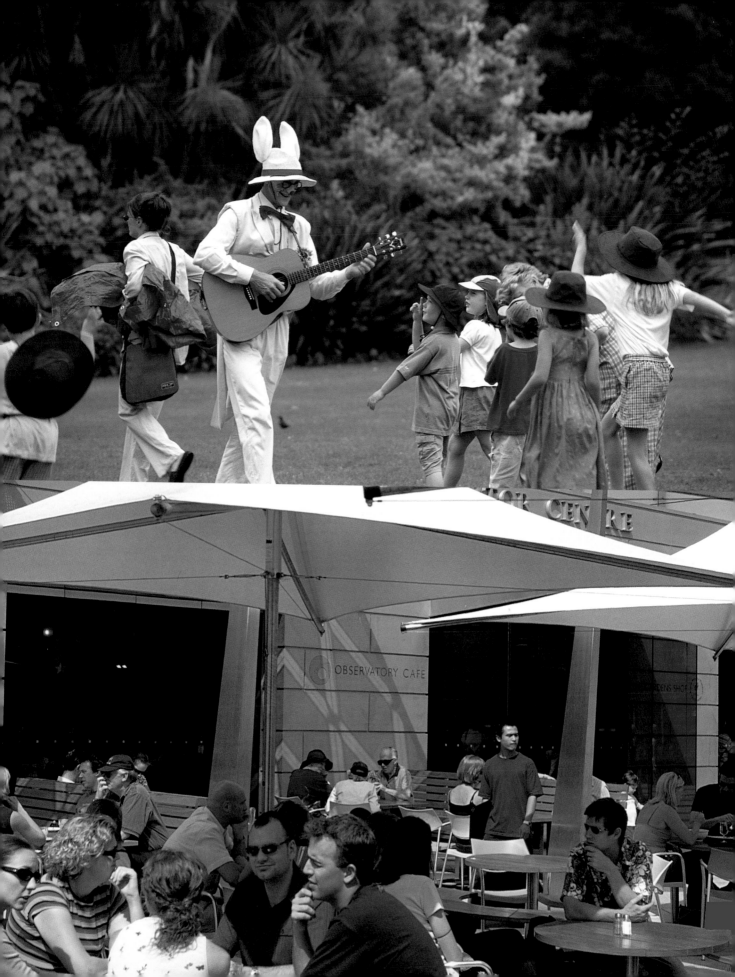

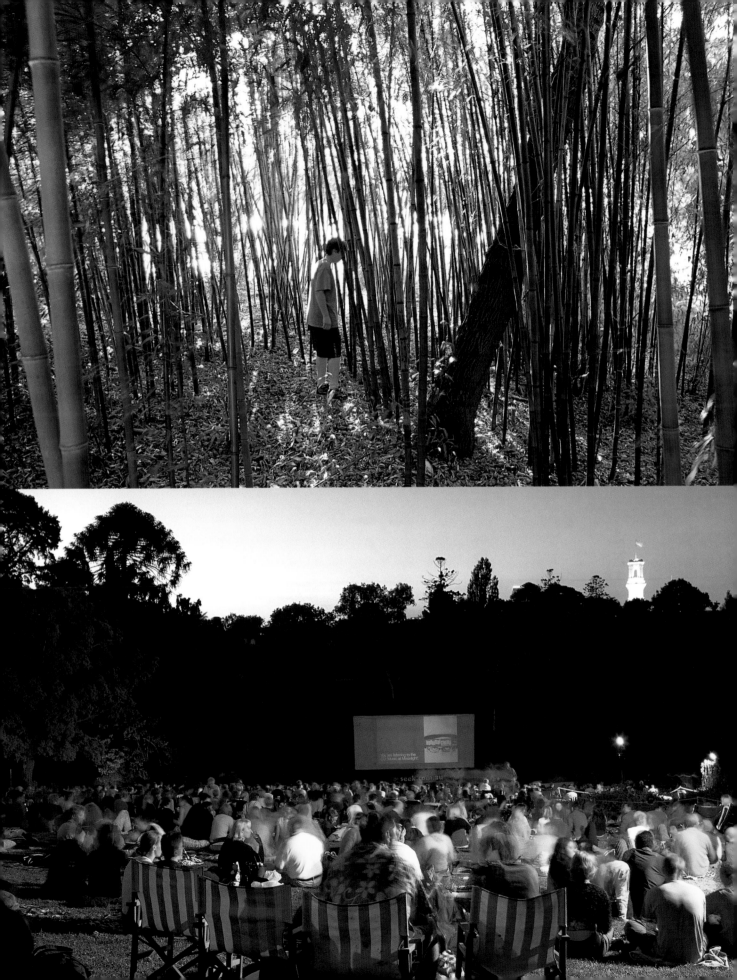

separation of Victoria from New South Wales. In 1954, Her Majesty Queen Elizabeth II planted a Queensland Brush Box (*Lophostemon confertus*), and four years later, granted approval for the Gardens to be known as the 'Royal Botanic Gardens'. To commemorate this event, a double tree-planting ceremony took place on the Eastern Lawn, when Sir Dallas Brooks, Governor of Victoria, planted a specimen tree of the Claret Ash, *Fraxinus oxycarpa* 'Raywood', and Henry Bolte, Premier of Victoria, planted a specimen of the Australian Blackwood, *Acacia melanoxylon*. These trees were planted in approximately the same area where the first plantings took place in the Gardens more than 110 years before.

The Gardens has also been used as a venue for concerts and music recitals since early in its history. Demand for its use increased during World War I when so many people turned up for patriotic band recitals that numbers had to be restricted. Too many visitors all at once tended to wreak havoc on the lawns and plantings. It was suggested by the government that the site of the recitals be moved to the Domain. In 1930, the government submitted a proposal that the Melbourne Symphony Orchestra should conduct regular free concerts in the Gardens. A number of recitals were held, culminating in a performance in March 1931 when the huge crowd caused considerable damage. Strong protests to the minister suggested that alternative sites in the Domain or the lawns of Government House be found, but it would be another 25 years before a new site was established.

The idea of using the Gardens as a site for public music recitals was revived during Alex Jessep's period of directorship (1941–57). An inspection was made by Melbourne's Lord Mayor and a fellow councillor in 1942; they were looking for a spot for a proposed 'Hollywood Bowl' rotunda where fortnightly orchestral concerts would be given by the players of the Albert Street Conservatorium. However, Mr Jessep stated in a report to the Department of Crown Lands that 'under no condition do we want the Botanic Gardens transformed into a joint picnic and amusement area'. In his opinion, botany and music didn't mix. The idea was shelved again, but brought forward from time

Previous page: Three popular summertime activities: dancing with 'Rabbit' in Wind in the Willows, *lunching at the Observatory Cafe, and enjoying a picnic at the Moonlight Cinema. Top right is the Bamboo Bed.*

"Of all the entertainments offered in summer time to the pleasure seeking people of Melbourne, none offer more picturesque attractions than the concerts held about full moon in the Botanic Gardens."

to time until, in 1945, the Victorian Government and the Melbourne City Council produced a series of orchestral and vocal concerts in the Botanic Gardens. The 'Music for the People' concerts were held in summer on a covered stage at the top of the Central Lawn. Attendances of up to 120 000 people were usual, and the concerts were considered a great success. Unfortunately, the impact of so many people at one time again caused damage to the Gardens. After more protests from the Gardens' administrators, a new venue was constructed in the Domain area in 1959. The Myer Music Bowl has been used for concerts of all types ever since.

Today, the Gardens are regarded as one Melbourne's most popular tourist destinations. Visitors come to relax in the glorious setting and appreciate the

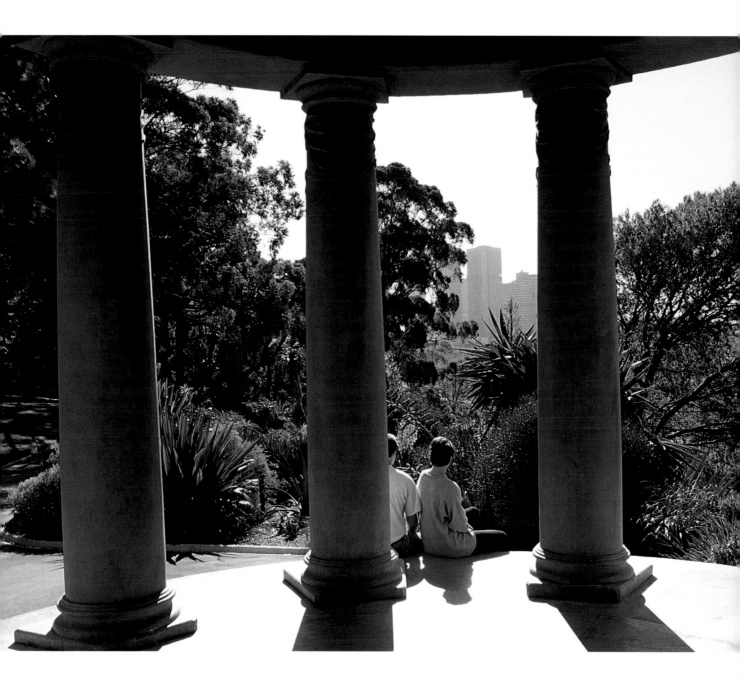

Above: Looking from the Temple of the Winds toward the Melbourne skyline, summertime.

Right: Many of the early residences in the Gardens' grounds remain and some are used as staff offices. Pictured here (clockwise from top) are the William Tell Rest House, the Plant Craft Cottage (the under-gardener's residence in 1850), Gardens House (once the Director's residence) and F Gate Lodge.

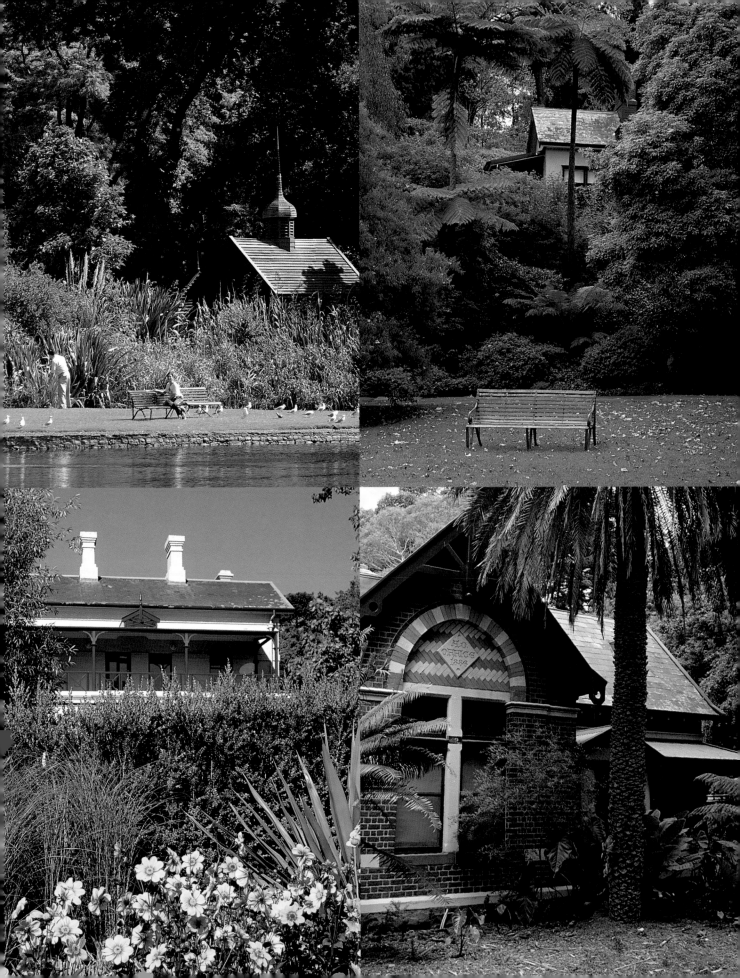

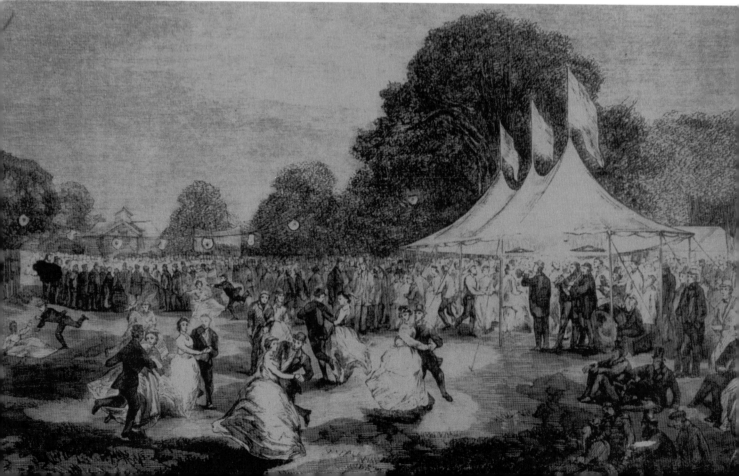

tranquility and beauty. It is still a meeting place for parents and children, who love to frolic in the autumn leaves, feed the eels and ducks in summer, marvel at the great oak trees, and run up and down the slopes to the Ornamental Lake just as they have done for more than a century. Lovers come to snatch a quiet few moments. Those interested in horticulture – both the professional and the amateur gardener – wander through, looking and learning.

For those who want to learn more, the Gardens holds a number of walks and tours that introduce visitors to its history, cultural significance and abundant horticultural diversity. One of the most popular is the Aboriginal Heritage Walk, where visitors are accompanied by an Aboriginal guide who can provide a unique perspective to what was once a traditional camping and meeting place for the Bunurong and Woiworung peoples.

Other special interest walks are led by voluntary guides, and cover topics such as the scientific achievements and exploration journeys of Baron Ferdinand von Mueller. The Gardens Highlight walk offers interesting insight into many of the plants.

Located at the Old Melbourne Observatory, the Observatory Gate is a significant development which allows public access to an important part of Victoria's scientific heritage. The restored astronomical buildings include a visitors' centre, a restaurant and a shop. And the kiosk near the Ornamental Lake is still a popular spot with visitors, who feed the eels that have lived there for millennia.

In summer, the Moonlight Cinema has taken the place of those nineteenth-century moonlit balls, while wandering down to the 'Bot' to see live performances of *Romeo and Juliet*, set against the dramatic background of the Gardens at sunset, is hard to beat for pure drama and romance. Children have their own theatrical adventures, following Mole and his friends in the *Wind in the Willows*.

And the people of Melbourne still come to the Royal Botanic Gardens Melbourne to celebrate, whether it be a wedding, a birthday party or a family picnic. Some things never change.

Left, top: Many dignitaries have planted trees in the Gardens over the years. Here, 'Madame Melba' (before she became Dame Nellie) and 'Miss Clark' plant a tree in 1903, alongside the Director, William Guilfoyle. (Library, RBGM.)

Left, bottom: A drawing of the dancing which concluded the Eight Hours Fête in Easter 1867, which was attended by more than 6000 people. (Library, RBGM.)

MANAGING

NATURE

CHAPTER SIX

ALTHOUGH THE ROYAL BOTANIC Gardens Melbourne has been blessed from the beginning with its site, it is still, after all, an artificial construction. Landscape architects, gardeners and arborists have been harnessing nature here for more than 150 years.

Water features have always been an integral component of the Gardens' landscape. Lagoons and lakes, fountains and streams played their part in creating the fantasy of the perfect 'natural' world. Perhaps turning the lagoon into an ornamental lake has created the biggest landscaping challenge.

Ferdinand von Mueller planted New Zealand Flax (*Phormium tenax*) along the lagoon's margins, considered introducing *Pampas gynerium* for its picturesque effect, and made island sanctuaries for nesting waterfowl. William Guilfoyle saw the lagoon as not so much a refuge for wildlife but a focus for his landscape design, and took advantage of the natural water features by transforming them into a series of romantically inspired imitations of nature. This included reshaping and clearing the marshes from the former swampy lagoon to create an ornamental lake, and accentuating picturesque views across a vast reflective sheet of water. Weeping Willows (*Salix babylonica*) were planted around the lake's banks and Central Lake was reshaped with small peninsulas of rock. The promontories that divided the main lake from the central lake were considered by Guilfoyle to be too long and 'monotonous', so in 1876 they were widened and raised. A single-arch bridge replaced Mueller's long iron bridge, to harmonise with the picturesque scenery that Guilfoyle wanted to create here. River Red Gum beams were placed on stone piles and the arch was faced with irregular pieces of cork to give the appearance of rockwork. A rustic railing was made from tree limbs that had been cleared from around the Gardens.

At the same time, the islands around the lake were enlarged. A large Aleppo pine (*Pinus halepensis*) was relocated to feature on one of the islands and Guilfoyle proposed planting rhododendrons, azaleas, magnolias, scarlet flowering gum (*Corymbia ficifolia*) and jacaranda to introduce that 'warmth of colouring so necessary to the finish of a perfect picture' and to 'vary the monotony of the Pampas Grass'. The water's edge was planted with Egyptian

Paper Reed (*Cyperus papyrus*), *Nymphaea alba* and Nile Trumpet Lily (*Zantedeschia aethiopica*). A small stream that originally fed into the lagoon was incorporated into the Fern Gully as a naturalistic creek and the Nymphaea Lily Lake was created at the head of its course in the Southern Lawn.

Ornamental Lake, distinguished by its highly varied serpentine edge, promontories and islands that divide the large space into many scenic vistas, now comprises three distinct sections. The main lake covers the largest area, stretching between the Hopetoun and Tennyson Lawns, while Central Lake links the Fern Gully and the main lake. The backwater is the narrow arm that bends around Long Island.

Nymphaea Lily Lake is the focus of views in the Southern Lawn. Originally larger, unwalled and featuring extensive plantings of water lilies and reeds, both in the water and at its margins, it offered a more naturalistic effect. Today, the treatment is much simpler, but the ornamental display of water lilies continues.

One of the most traditional ornamentations of Picturesque garden design, the fountain, has been the stuff of dreams for many of the Gardens' Directors. Back in 1858, Mueller reported to the government his intention to enhance the beauty of the lagoon by installing fountains, for which he had developed a penchant while travelling in Europe. Only one of Mueller's fountain dreams came about. A fountain – or, to be more precise, a jet of water some 15 metres high – was installed on an island in the lagoon, now known as Fountain Island. The fountain was eventually put out of action when the free Yan Yean water supply to the Gardens was restricted. Later, an improvement in the water supply directed attention to the possibility of what the next Director, William Guilfoyle, envisaged as 'one grand fountain in the centre of the gardens'. Like

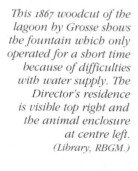

This 1867 woodcut of the lagoon by Grosse shows the fountain which only operated for a short time because of difficulties with water supply. The Director's residence is visible top right and the animal enclosure at centre left. (Library, RBGM.)

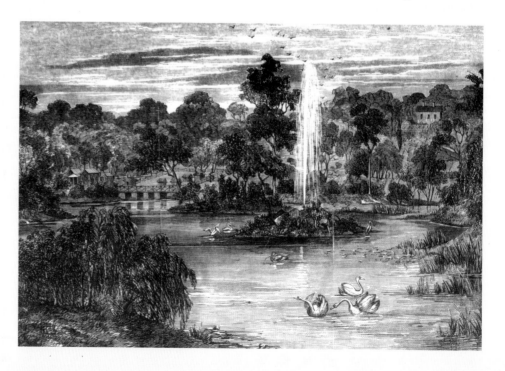

his predecessor, he had in mind the great fountains of private and public European gardens. And, like Mueller, he was to be disappointed that one was never installed.

According to Richard Pescott, Director from 1957 to 1970 and the Gardens' historian, there seems to be a history of resistance to fountains at the Gardens. Following a visit to England and Europe in 1963, Pescott proposed that a series of water jets be installed in the Ornamental Lake, but nothing eventuated. 'It cannot be denied that the introduction of moving water, whether in the form of a fountain, a jet of water, or just bubbling water, brings life and interest to an otherwise static pool, very often dark and inanimate,' he wrote in his 1982 book on the Gardens. The exception to the 'no fountains' policy at the Gardens is the small fountain, designed to resemble the flower of a hibiscus, which was constructed with private funds in the Nymphaea Lily Lake.

But managing and harnessing water has proved a much larger problem than planting and designing lakes and streams. Probably the biggest issue that successive Directors have faced since the first Curator, John Arthur, started planting trees has been water. Floods and droughts have stretched resources to the limit, and finding a constant supply of water has always proven a huge challenge.

In the early days, flood was more of a problem than drought. The Yarra River, which provided for the Gardens, was also a potential enemy. When European settlement first began, the Yarra was fed from a small creek that trickled in from the north of Melbourne. Although dry during good weather,

Below: Gardens' workers take a break from some heavy work, c.1905. The men were probably digging on the site of the Tea House or Tea Pavilion (both opened in the early 1900s) or excavating the Central Lake. (Library, RBGM.)

Overleaf: Ornamental Lake in April – one of the last sunny Sundays before the onset of winter.

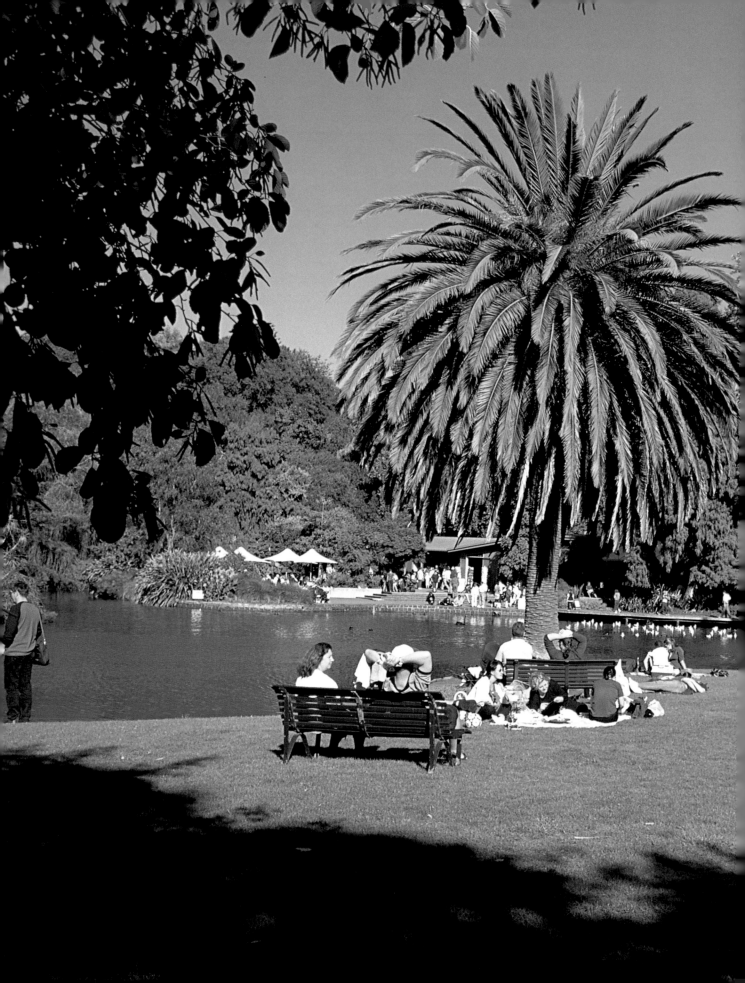

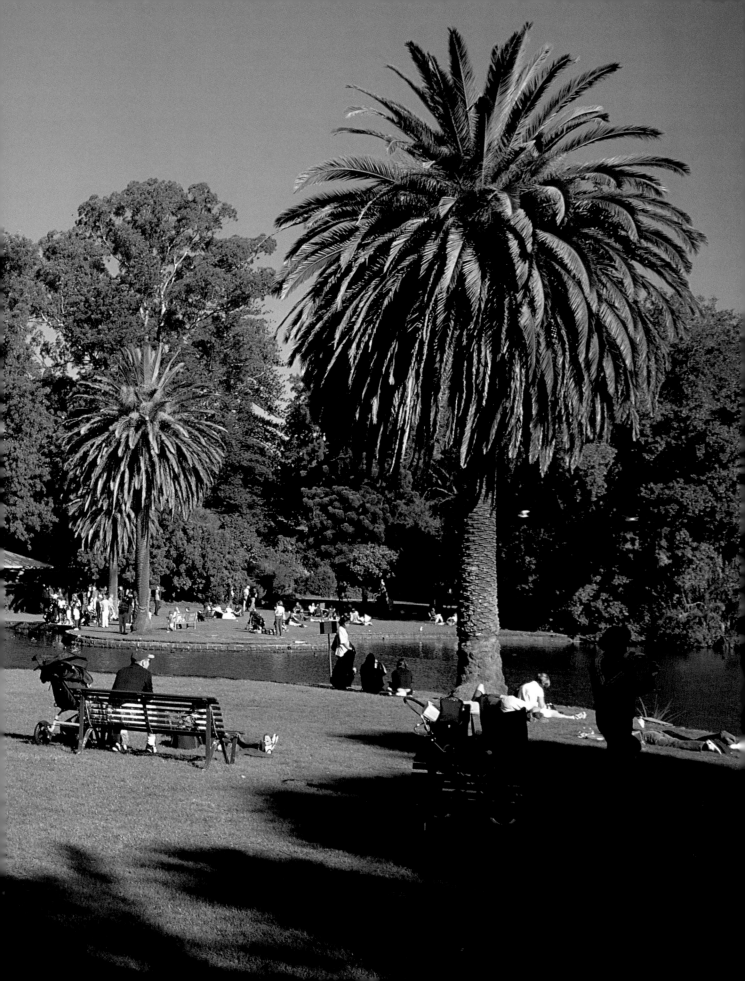

PEOPLE OF THE GARDENS
Katie and Bert Sandford

Katie Sandford came to the Botanic Gardens in 1924 with her husband, Bert. Bert and another carpenter restored two pavilions – the Rose Pavilion (or Bandstand, as it was then known) and the Bougainvillea Rest House, which was severely damaged by a falling limb and demolished in 1969.

'My husband, Bert, worked in the Gardens from the time he was eighteen years old, in about 1924 … Gardens House [the Director's residence] was pretty bad. I mean the kitchen, well you couldn't imagine how three people could fit in at once, there was no room to do anything. The floor was all stone and the toilets were outside and the bathroom was outside. The gas was on and it had electric light, but the copper was outside in the laundry washhouse … The people weren't very sociable, probably because they were so many years older than me and I had a young baby. They never bothered to come around and say "Hello, are you alright" or anything like that, they kept very, very much to themselves … I can remember Percy St John, but although he lived in the Gardens I only ever saw him once. I was very isolated in that place. I was very particular in making sure my baby had a rest every day, so I used to walk all around the Gardens with the baby in the pram, that was all my pleasure. I couldn't cross the main road – it was too busy, even in those days.'

'[The bell] would ring at night at closing time, and the night watchman, Fred Williams, would have to make sure to lock the gate [to the Gardens]. Fred Williams used to come around and sometimes you would find people still in the Rotunda hiding, and in [Fern] Gully, as well … it was a bit frightening because sometimes you would get a knock at the door and it would be someone who had been left in the Gardens. Sometimes they had to get the police there. There had been a murder in the Gardens just before we arrived. Tom Neath's son told Bert about

it. He was quite a young boy at the time and was living in the Eastern Lodge. His father came rushing out to shepherd him indoors, as a man had gone mad and there were bullets flying everywhere. The police from South Melbourne were there quite a lot for different occasions – you know, people that were exposing themselves and things like that. There was quite a lot of that went on in the Gardens, and I had a special number in the kitchen if anything happened. This one day they brought over a man who had tried to commit suicide by jumping off the bridge and throwing himself in the Yarra. They put him onto my front verandah.'

'Bert started off at the Gardens as a labourer. He worked with the men who did all the gardening, all the ground work, all the cement work, all the paths. He mended the roofs, he did carpentry work … then he graduated to B section, that was his section, the Australian section. Everyone in the Gardens had a section and they were not rotated at all, they stayed in the one position … Bert could see no future in the Gardens unless he studied. He studied and studied. He went to Burnley and he learnt how to bud and graft and all those jobs … We never went out – we couldn't afford to go to the pictures or anything like that – so, as soon as the children went to bed at about 7.30 at night, we would sit down and all the books would come out. Bert studied plant pathology and entomology; he built that roll-top writing desk himself and he had it full of insects, all named, so he deserved really to get on. He loved the Gardens and he loved the trees.'

the river flowed fiercely during winter and heavy rains, and for the first 30 years of settlement there was widespread flooding. Downstream, the Yarra meandered between lagoons, and as the Gardens' lagoon filled in heavy rain, the Gardens themselves suffered continual flooding.

Mueller was the first to address this problem. A devastating flood in 1863 showed the need to raise the Yarra River banks along the length of the Gardens and silt was excavated from the lagoon for that purpose. After levelling the flood debris, the excavated soil was used to transform the swampy northeastern portion of the Gardens into a lawn for picnic parties arriving by boat. Flood again influenced planting along the northern boundary after fences were washed away in 1868. A dense belt of vegetation was required to consolidate the banks and offer some protective shelter. In his report of that year Mueller noted that:

> Tall Danubian Reeds, Callas, patches of Tea-tree (Melaleuca ericifolia, transferable in an upgrown state), Poplars, Ashes, Elms, Oaks all of various kinds, Toi-Toi, Pampas Grass, Tamarix, Ampelodesmos, Wiry Muehlenbeckia, Poa ramigera, will ere long impress on the once dismal swamps and river banks a smiling feature.

The Yarra River was eventually realigned and deepened to alleviate the problems with flooding. Work began in 1897, and continued for three years, to alter the northern boundary of the Gardens by straightening the river. The picnic ground and the northeastern end of the lake, as well as the large island of melaleuca scrub, became part of the newly constructed Alexander Parade and the Yarra River, while the former south bank of the river became Long Island.

But, as well as flooding, the Gardens has always been vulnerable to drought and an unreliable water supply. During the early days, water was carted from the Yarra River, with rainfall the only supplement. The river was freshwater at that time. The downstream tidal barrier was later demolished so the river became saline up to Dight's Falls, north of the Gardens. By the time of Mueller's appointment, it was apparent that a formal water supply system was necessary. A causeway built to protect the lagoon from flooding had cut its natural flow.

After some experimentation with pumping devices, Mueller proposed using a small ornamental windmill to pump water from the river to the lagoon. He also intended to use windmills to pump water to the higher parts of the gardens. One windmill was constructed on the northern side of the river to supply water to a fish tank.

When a new reticulated freshwater supply from the Yan Yean Reservoir reached Melbourne in 1857, Mueller realised the great benefits it could bring to the Gardens, not only for watering, but also for running his fountains. While waiting for the supply to be connected, he placed tanks and cisterns at all the principal buildings to catch rainwater. The Yan Yean supply, originating from the Yan Yean Reservoir, was connected to the Gardens in 1860. But supply was unreliable so water could only be used late at night, when the pressure exceeded 40 pounds per square inch. Mueller's geyser fountain could only operate for two

hours in the afternoon in cool weather and was further reduced to working on Sundays only. By September 1868 it was inoperable. During those years, the plantings were saved by using water from the various cisterns, and waterholes sunk into the clay soils on the higher part of the ridge. Even the unreliable Yan Yean supply wasn't to last. Because the Gardens used considerable quantities of water, the supply to surrounding suburbs was severely affected, so nearby councils supported its disconnection from Yan Yean to improve the supply to residents.

The irrigation pipes now carried water from the Yarra River. When Guilfoyle became Director in 1873, he began discussions to establish a new water supply. The dry summer of that year and the next forced him to again use most of his labour watering plants. 'Both in the Domain and Botanical Gardens the inadequate supply for both places should be speedily arranged,' he reported. 'During the drought last summer, there being no Yan Yean supply to the Botanical Gardens, the men were almost exclusively occupied in keeping the plants alive, not having time to attend to keeping the grounds in order, or perform other necessary works.' Without the Yan Yean supply, not only were there limited

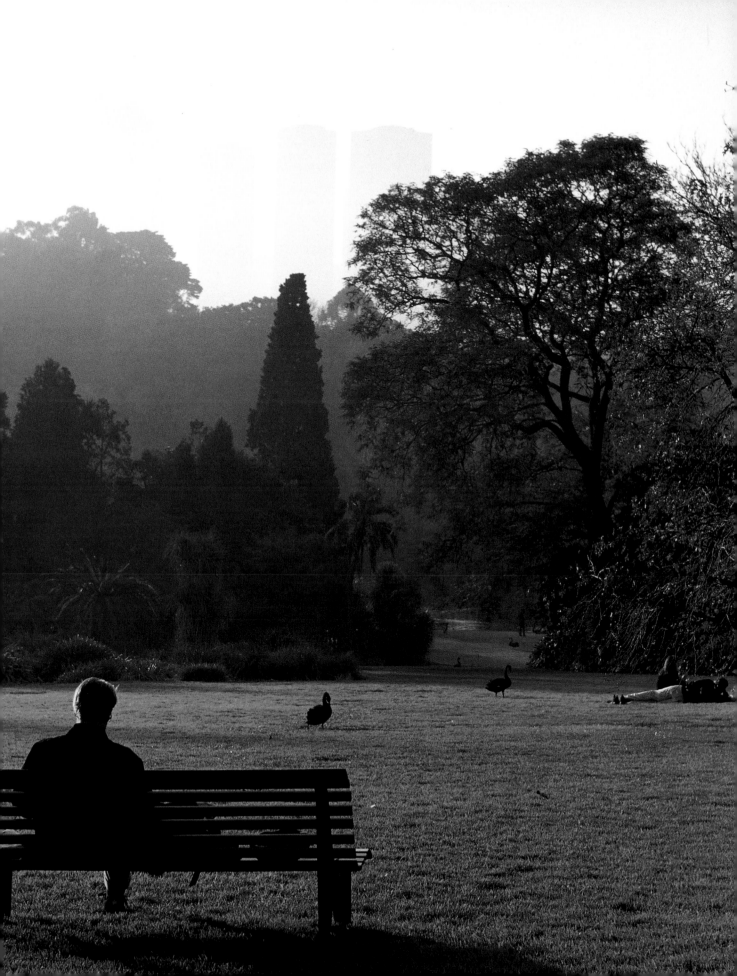

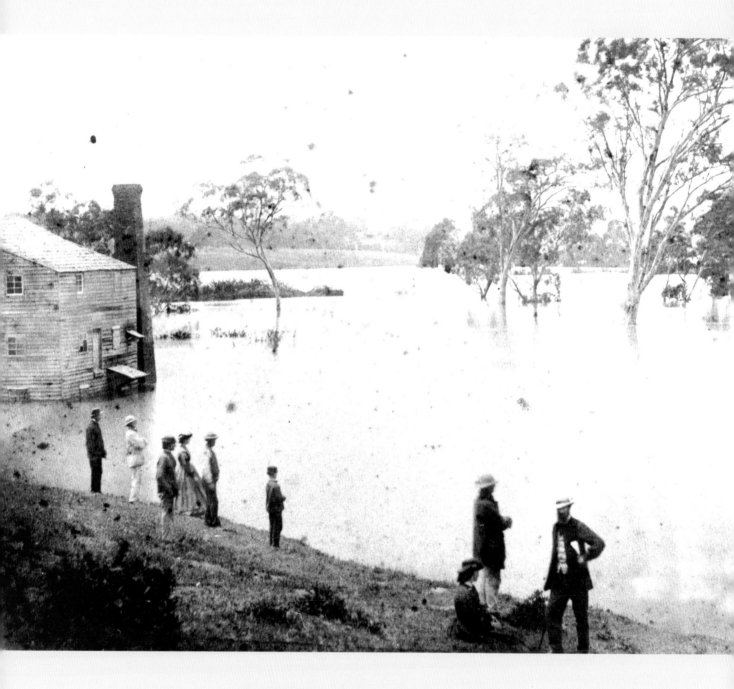

*Above: Before the Yarra River was straightened the Gardens was very susceptible to flooding.
Pictured here is the Richmond flood of December 1863 which flooded much of the Gardens.
(Library, RBGM.)*

*Previous page: Each year several thousand cubic metres of fallen leaves, branches and
prunings are turned into mulch at the Gardens' Greenwaste Recycling Centre.*

amounts of Yarra River water available for horticultural purposes, but there wasn't adequate drinking water in the Gardens. At one stage, reported Guilfoyle, 'at the bridge crossing the lagoon, a tap and ladle have been temporarily placed, supplied with drinking water by a syphon from one of the tanks of rain at the Director's house'. Guilfoyle was forced to use water carts for general watering, obtaining supplies from any available source, including the lagoon.

Construction of a new water-supply scheme began in June 1874, in the form of a new reservoir in the Gardens themselves. A 250 000-gallon capacity conical bluestone-lined reservoir was completed the following year, which would be sufficient for several days' watering, but the new engine to supply it hadn't been built, so the reservoir couldn't be used effectively until 1877. Guilfoyle landscaped the area northwest of the reservoir to represent a volcanic scene, with the reservoir acting as the central cone and arms of lawns and garden beds used to emulate lava flow. Today, the reservoir is the only part of this early system to survive and plans are afoot to redevelop it as a publicly accessible landscape feature.

This new supply of water again failed to live up to expectations. The reservoir filled slowly because its supply pipe was too small. The engine pumped water in a fixed ratio, the left pump to the lagoon and the smaller right pump to the Gardens, which restricted the system's flexibility to pump where water was most needed.

However, the greatest threat to the Garden's water supply emerged in 1883, and resulted in Guilfoyle abandoning the pumping of water from the downstream reaches of the Yarra. A series of rock and hard clay reefs known as The Falls (the main reef started at Falls Bridge) that prevented salt water going further upstream, also prevented floodwaters discharging freely from the Yarra. Work on removing The Falls commenced in 1883 and reached completion in early 1890s. As more reefs were gradually removed and the river deepened, the tidal influence upstream became more pronounced. The water was still predominantly fresh, but it was becoming increasingly tidal. This worried Guilfoyle, who wrote to the Secretary for Lands requesting a professional opinion be sought to find ways to prevent damage to the plants. But no action

was taken; work to remove the reefs continued, and by 1887, the water was very salty. By 1889, Guilfoyle was asking the government 'when the scheme for supplying water from Dight's Falls will be completed as it necessary to save the collection of Palm trees and shrubs, ferns, etc'.

His worries were shared by those industries that also depended on a supply of fresh water. The paper mill of Brooks and Currie, which was located on the south bank of the Yarra between The Falls and Princes Bridge, had petitioned the government back in 1883, suggesting that fresh water be pumped from Dight's Falls to supply the mill and the Gardens. No action was taken until 1889, when the government finally agreed to the construction of the Dight's Falls scheme. It took three years to build, with many setbacks, including floodwaters inundating the pumping station in 1891. The scheme began supplying free water to the Gardens around the end of 1892 and greatly improved the quality and reliability of the water supply. It continued to operate all year round until 1931, when the Melbourne and Metropolitan Board of Works decided to supply the Dight's Falls system from the metropolitan water mains. Once again, the Gardens received its water from the domestic supply.

For a long time, water was free, but when that changed, irrigating the Gardens became problematic. It was not only because of cost but also the diversity of the landscape, which comprised mature specimen trees, broad expanses of lawn and detailed garden beds. Until 1992, it was estimated that up to 70 per cent of a horticulturist's time over summer could be spent just moving hoses and sprinklers across the Gardens' 38 hectares. Most of the irrigation was carried out during the day and there were relatively short shifts between sprinkler rotations. It is unlikely that sufficient amounts of water were applied to adequately wet the full root-zone depths – particularly in the garden beds – and large of amounts of water simply evaporated.

Today, the Royal Botanic Gardens Melbourne is one of the first gardens of this size in the world to have an automated, large-scale watering system. Completed in 1994, the system comprises seventeen satellites, 434 valves and about 6000 sprinklers. Almost the entire space gets water through the system,

Right: Australina Grass Tree (Xanthorrhoea australis).

which can be upgraded with new models of sprinklers, thus ensuring that the technology doesn't date.

To aid effective irrigation and water conservation, it is vital that those who operate the water system are able to access accurate and site-relevant evaporation information. Originally, the Gardens relied on information supplied by the Melbourne Bureau of Meteorology, but this wasn't specific enough. In February 1998, an automatic weather station was installed in the grounds of Government House; it was eventually relocated to the newly developed Observatory Gate precinct a year later. The Gardens' weather station has proved invaluable in providing accurate, site-specific information on rainfall and evaporation. It can also provide details of rainfall intensity, which can assist in assessing water infiltration of soil and run-off data during storms.

Water, in all it shapes and forms, has proved one of the Gardens' biggest challenges in terms of both landscaping and irrigation. Besides the huge amount of turf, there are over 52 000 individual plants to be cared for, which represent a diverse 12 000 species from all around the world. Some are rare or endangered; all have very different water requirements. No longer is managing nature a matter of buckets and hoses – it now requires a cutting-edge technological approach to keep the Gardens alive and healthy.

The establishment of a recycling centre has been another recent improvement in water management and conservation. In a forest, fallen leaves, branches, flowers and fruit are broken down by soil organisms such as worms, fungi, millipedes and bacteria. The result is a compost that returns organic matter to the soil and nutrients to the plants. In a botanic garden, the result is an untidy mess, which would probably prove displeasing to most visitors' eyes. When mulch is used, however, it reduces the need for watering, as it minimises the amount of moisture lost from the soil. It also stabilises soil temperature, which improves conditions for root growth.

Recycling was only recently introduced to the Gardens. Until 1994, prunings and cuttings were often taken to a tip; woodchipping was only begun

in the late 1980s. The Greenwaste Recycling Centre (built with funding provided by EcoRecycle Victoria) found its permanent site only in 1998. These days everyone at the Gardens is committed to recycling and waste minimisation.

Each year, several thousand cubic metres of fallen leaves, branches and prunings are collected and taken to the Greenwaste Recycling Centre. Based on the natural process of decomposition, the recycling centre promotes public awareness and educates visitors from both the public and industry. Green waste is laid out in a windrow – a long, wide row of 300 cubic metres of milled material. The heap is turned every seven days using a front-end loader and its temperature is monitored to ensure it reaches 55 degrees Centigrade or higher for three consecutive days to eliminate weeds and plant diseases. The temperature at the heap's centre determines which micro-organisms are present and how quickly they decompose the organic material. Altogether, the green waste is turned three times and on the 28th day a high quality, composted mulch is ready to be spread on garden beds. The centre has an impervious clay base so that leachate (water run-off from compost) doesn't enter the ground and pollute the nearby Ornamental Lake.

"Until 1992, it was estimated that up to 70 per cent of a horticulturist's time over summer could be spent just moving hoses and sprinklers across the Gardens' 38 hectares."

STUDYING

NATURE

CHAPTER SEVEN

SCIENTIFIC BOTANY IS AN INTEGRAL part of Australian history. A young, wealthy gentleman and botanist, Joseph Banks, joined Lieutenant James Cook on the first exploratory voyage to Australasia, bringing with him, at his own expense, botanist Daniel Solander, naturalist Herman Sporing and two artists. Banks returned home with a large collection of botanical and zoological specimens and established his London home as a museum of the *Endeavour* collection. Solander became Banks' secretary and librarian, and the collection was made available to other scientists.

Banks had planned to join Cook again on his second voyage in the *Resolution* for its expedition to the southern reaches of the Pacific and Atlantic Oceans, but fell out with him and the Admiralty over the ship's design and the lack of accommodation for his scientific party. Even so, the Admiralty sent an astronomer, two botanists and an artist. Not to be outdone, the French sent three large scientific exploring expeditions to the Pacific and Australasia between 1777 and 1802; the final voyage, commanded by Nicolas Baudin, included geologists, astronomers, botanists, zoologists, anthropologists and natural history and landscape artists.

Banks quickly came to dominate the continued scientific exploration of Australia well into the nineteenth century. He corresponded with the governors of the new colony of New South Wales, encouraged further exploration and collecting, and ensured that a continuing flow of botanical and zoological specimens found their way to his private collections and to Kew. In 1798, Banks sent his own collector, George Caley, to undertake a systematic collection of Australian plants. He orchestrated the 1801 expedition by navigator and surveyor, Matthew Flinders, to chart and explore the southern and western coast of Australia and personally selected its naturalist, Robert Brown, and botanical illustrator, Ferdinand Bauer.

The Australian continent challenged European concepts of order, of both the plant and animal world. British botanist Sir James Smith noted in 1793 that:

When a botanist first enters … so remote a country as New Holland, he finds himself in a new world. He can scarcely meet with any fixed points from whence to draw his analogies. Whole tribes of plants which first seem familiar … prove, on a nearer examination, total strangers, with other configurations, other economy, and other qualities; not only the species that present themselves as new, but most of the genera, and even natural orders.

Botany dominated the expeditions and early collecting in the colonies for a number of reasons. Botanical collection was much simpler than capturing and preparing zoological specimens, and dried botanical specimens could easily be shipped back to Europe. Botany also had a clear practical purpose, as Kew Gardens became the centre of a network of exchange to find new plants of potential economic value.

Science and technology were an increasingly important aspect of colonial society and culture, regarded by many as a measure of the degree of civilisation that had been brought to this wild land, and of the economic and social improvement that had been achieved in the colony in a few short years. The Botanic Gardens, the Great Melbourne Telescope, the museum and the State Library's domed reading room became powerful symbols of those achievements, showing Melbourne's ability to emulate the institutions of London and the Continent.

In Victoria, Charles La Trobe, described by a contemporary as 'a man of a thousand occupations: a botanist, a geologist, a hunter of beetles and butterflies', played his part in fostering the growth of 'civilisation'. As Superintendent of the Port Phillip District, he was not only responsible for selecting the site of the Botanic Gardens in 1845, he was also instrumental in the appointments of Alfred Selwyn as Government Geologist (1852), Robert Ellery as Government Astronomer to the new Williamstown Observatory (1853) and Ferdinand von Mueller as Government Botanist (1853). As well as helping with the creation of the natural history museum and the University of Melbourne, he was patron of Victoria's two Philosophical Societies.

"During his 44 years as Government Botanist, Mueller named and described more than 2000 new species – roughly one new species each week."

From its inception, the Botanic Gardens was seen as a place of both education and recreation, and each function reinforced the other. To walk through the Gardens was to see a scientific order placed over nature and, at the same time, to see nature arranged into a pleasing landscape, with Australian flora integrated into the aesthetics of European landscape gardening. And there was always an emphasis on the contribution of science. For the latter part of the nineteenth century, the Gardens' Herbarium and the Observatory were Melbourne's dominant scientific institutions, along with the natural history museum.

Scientists came to occupy a central place in Victoria's culture and Ferdinand von Mueller was highly influential. No study of the Gardens would be complete without acknowledging its huge debt to him. His appointment was a focal point in the history of scientific botany in Australia. During his 44 years as Government Botanist, Mueller named and described more than 2000 new

Overleaf: The Water Conservation Garden on the Eastern Lawn demonstrates water-saving principles. It is planted with hot-coloured groundcover and shrubs, and large drifts of perennials are interspersed with succulent plants, such as agaves and yuccas. It is watered less frequently than other collections.

Water Conservation Garden

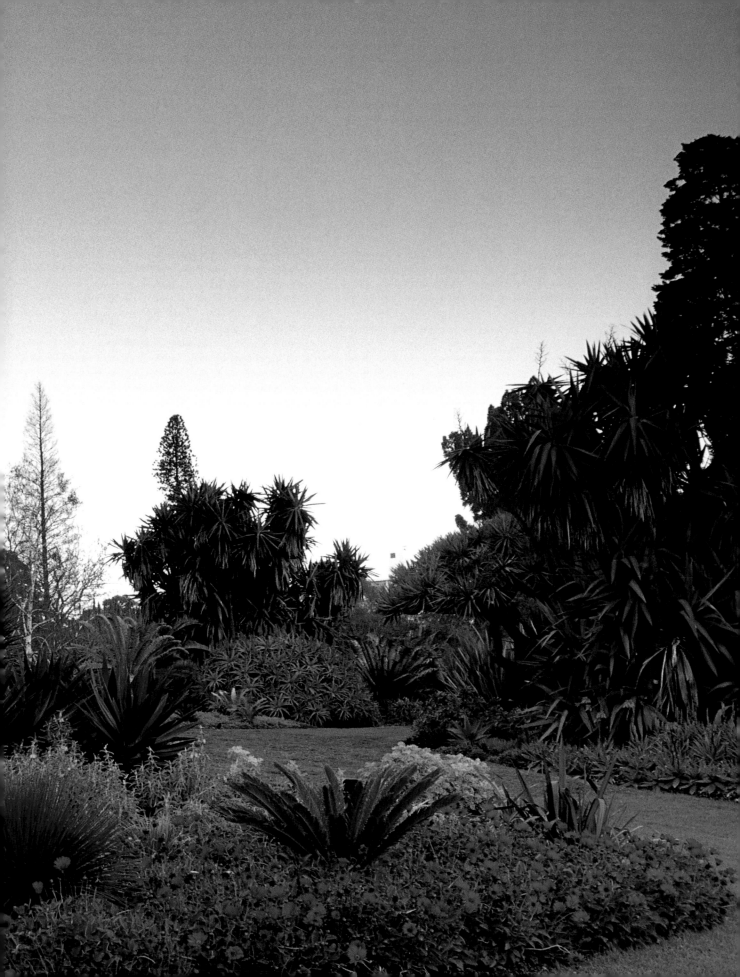

species – roughly one new species each week. In recognition of his contribution to botany, many plants have been named after him.

Mueller was also an extremely diligent correspondent. Through his cultivation of a network of contacts in both Australia and overseas, he exchanged information, specimens and seeds. In some years, he wrote as many as 3000 letters. One of Mueller's most significant acquisitions for the Herbarium was the Sonder collection, which represented nearly 40 years of work by the nineteenth-century German botanist, Dr O. W. Sonder. The Herbarium's other historical material includes specimens collected by Sir Joseph Banks and Dr Daniel Solander during Cook's 1770 voyage to eastern Australia, as well as material collected by Robert Brown, the botanist travelling with Matthew Flinders on the first circumnavigation of this continent.

From his base at the Herbarium, Mueller conducted surveys of the flora of Victoria, always with an eye to identifying commercially useful plants, whether as a source of timber, medicine, food or essential oils.

But government scientists at that time had to strike a balance between meeting the government's demands for immediate practical results and undertaking more long-term basic research. Mueller faced a particularly

Below: The National Herbarium c.1900. (Library, RBGM.)

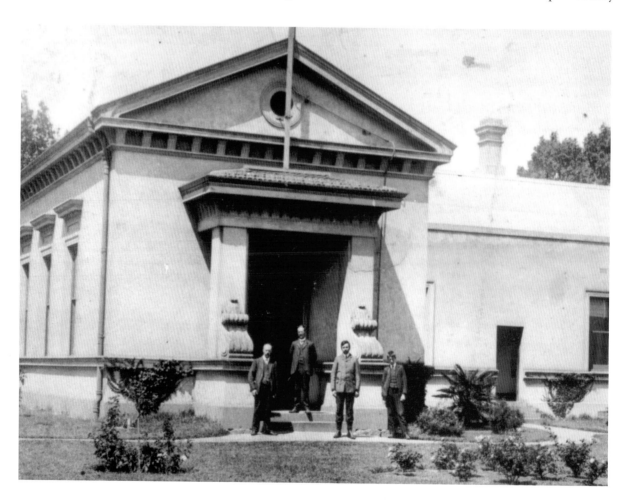

difficult balancing act as Government Botanist and Director of the Botanic Gardens. He argued in an address to industrialists in 1871 that the object of botanic gardens:

> must be mainly scientific and predominantly instructive. As an universal role, it is primarily the aim of such an institution to bring together with its available means the greatest number possible of select plants from all the different parts of the globe; to arrange them in their impressive living forms for systematic, geographic, medical, technical or economic information and to render them accessible for original information and careful records.

Mueller gave enormous assistance to George Bentham of the Royal Botanic Gardens, Kew, England in the first attempt to describe the flora of Australia, *Flora Australiensis*. The plant specimens from the Melbourne Herbarium were essential for the production of the *Flora*. They were sent to England, in progressive shipments, in sealed metal trunks, and Mueller worried incessantly that the ships would sink and his specimens would be lost. Compiled from 1863 to 1878 and covering 8000 species in seven volumes, *Flora Australiensis* remained in use without revision for 100 years. In the last twenty years, it has been progressively replaced with the new *Flora of Australia*.

After Mueller's death, the Herbarium went into decline for many years; both the duties of the Government Botanist and the significance of the position were downgraded. There were some highlights: the *Flora of Victoria* was published in 1931, the work of Professor Ewart, who had been both Government Botanist and Professor of Botany at the University of Melbourne. The Herbarium was also a major beneficiary of Victoria's centenary in 1934. The building in the Domain was cold, damp and cramped, and although it had been extended twice, its rooms were stacked to the ceiling with specimens. In 1934, a new building was constructed as a result of a contribution from prominent Melbourne manufacturer, Sir Macpherson Robertson. A modern building, with its outstanding dried plant collection and library, it was considered the best herbarium in the Southern Hemisphere. The Herbarium was extended in 1988,

as part of Australia's bicentennial commemoration, because the collections had once again outgrown the space available.

Interest in botanical research was revived when Dr James (Jim) Willis started work as a professional taxonomic botanist at the National Herbarium of

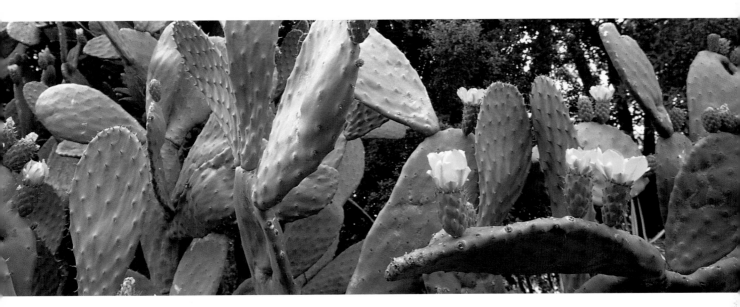

Victoria. A former forest officer with the Victorian Forests Commission, Willis commenced his 34-year career at the Herbarium in October 1937. He had increased contact with amateur and professional botanists and more opportunities to visit new areas. Like Mueller, Willis corresponded widely with interstate and overseas botanists and revelled in field expeditions to different floristic regions. He became the first editor of the Herbarium's research journal, *Muelleria*, editing the first three numbers from 1956. As his knowledge, research and publications grew, he received progressive promotions.

In May 1961, after spending fourteen months on secondment as Australian Botanical Liaison Officer at Kew Herbarium, England, he returned home to the

Left: Relaxing on Princes Lawn on a summer afternoon.

Above: Indian Fig Cactus (Opuntia ficus indica).

PEOPLE OF THE GARDENS
Maud Gibson

Maud M. Gibson, a Victorian by birth, was one of the daughters of William Gibson, who migrated with his wife to Melbourne from Scotland in 1880. Gibson became a partner in the firm of Foy and Gibson Ltd, Melbourne, one of the city's most prestigious department stores, and on his death in 1918 his daughter inherited a life interest in his estate.

Over the years, Miss Gibson lived in Australia, England and the US. Some time after World War II, she moved to Brissago, Switzerland. She died there on 5 April 1970.

Miss Gibson, always interested in the country of her birth, decided in 1945 to establish a trust – the M. M. Gibson Trust – in memory of her father, the recipient being the Royal Botanic Gardens Melbourne, which she and her father loved so much. It is now known as the Maud M. Gibson Gardens Trust.

The original charitable trust consisted of 209 fully paid, 6 per cent first-preference shares of £100 each in Foy and Gibson Pty Ltd – assets worth £20 000 – the interest from which was to be used for the benefit of the Gardens.

Over the years, many new projects, long- and short-term, were implemented, including the production of the memorial volume to celebrate the centenary of the Gardens, as well as films, books, botanical art, research programs and buildings.

In 1965 Miss Gibson made an offer of £10 000 over two years, to be used for research in relation to the work of the Gardens and the National Herbarium. This money was put into a separate trust – the Botanic Gardens Branch Research Trust. Further donations were made over the next five years, as well as bequests to the M. M. Gibson Trust and the Research Committee.

The Research Trust Committee has supported many research projects and paid for specialist staff members. It has financed important plant surveys throughout Victoria and helped finance the Maud Gibson Trust Molecular Systematics Laboratory. It has also commissioned artists to undertake the botanically correct paintings of a selected number of Australian species. Artist Celia Rosser, internationally renowned for her *Banksia* paintings, is only one in a line of highly respected artists to paint for the Royal Botanic Gardens Melbourne.

position of Assistant Government Botanist. For the last fifteen months of his service, he was Acting Director of the Royal Botanic Gardens Melbourne and the National Herbarium.

Dr Willis pursued his interest in Australian plants all his life. He researched and published on flowering plants and on lower plant groups, placing emphasis on mosses and fungi. In his taxonomic role, Willis described 42 new plant species and co-authored another 22 species, such as the new grass (Poa fax) that he and fellow Gardens botanist Arthur Court named in 1956. He kept meticulously compiled files on botanists, collectors and explorers, and his publications include many on the history of botanical exploration. He was an early voice for conservation and prepared floristic lists for local areas, as well as publishing descriptive accounts of vegetation. Exotic plants and horticulture

A detail of Trineuron nivigenum, *from Mueller's* Plants Indigenous to the Colony of Victoria: Lithograms. *(Library, RBGM.)*

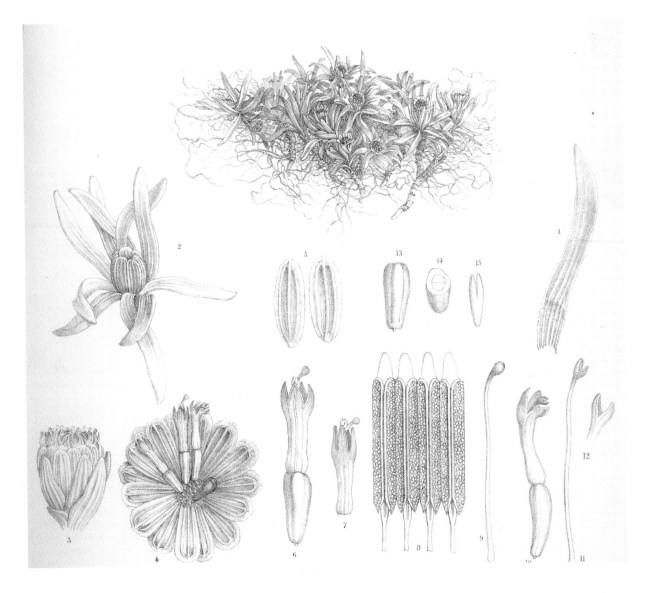

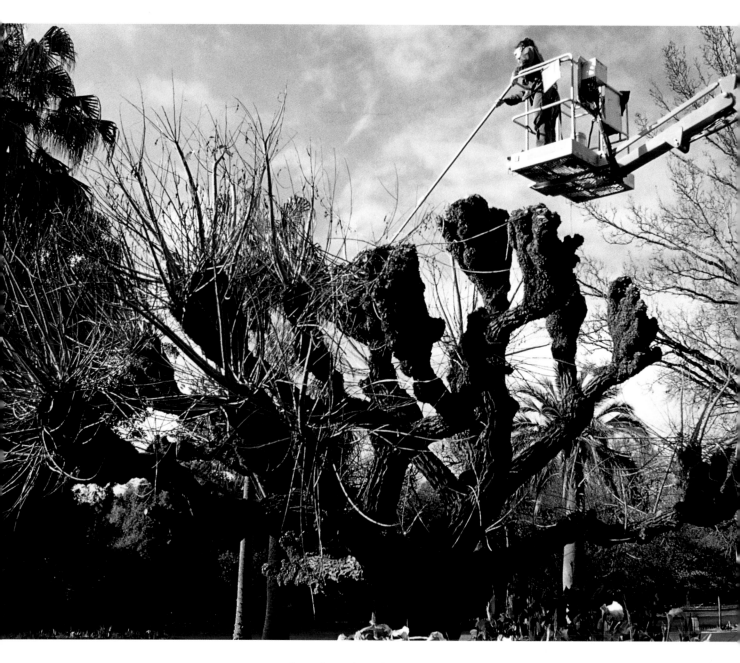

A Cockscomb coral tree (Erythrina cristagalli)*, adjacent to the Herbarium, is pruned in winter with a technique known as pollarding which stimulates dense flowering in early summer and produces its striking branch formations in winter.*

also received his attention; he totally revised E. E. Lord's book, *Shrubs and Trees for Australian Gardens*, for its fifth edition in 1982.

In all, Willis published over 800 books, scientific and popular papers, pamphlets, essays and reviews. His *A Handbook to Plants in Victoria, Volume 1* (1962) and *Volume 2* (1973) were milestones for Victorian botany, replacing A. J. Ewart's outdated *Flora of Victoria*.

Over the years, professional colleagues have named eight plant species in his honour, with the names *'willisii'*, *'willisiana'* and *'jamesiana'*. After receiving the Australian Natural History Medallion and the Royal Society of Victoria's silver medal for research, in 1973 he was appointed an Honorary Fellow at Monash University's Faculty of Science and awarded a Doctorate of Science from the University of Melbourne. He was made a Member of the Order of Australia in June 1995.

After Jim Willis' retirement in 1972, the position of Assistant Government Botanist remained vacant until 1978 when it was filled by Jim Ross, who is currently Chief Botanist and Divisional Director of the Plant Sciences and Biodiversity Division at the Herbarium.

The Gardens' nursery propagates many Australian and exotic plants, including the Sturt's Desert Pea (Swainsonsa formosa) shown here.

The National Herbarium of Victoria is now the Victorian State Government's major centre for botanical studies in plant identification and classification. It is an active and thriving centre, and contributes to many areas in botanical science.

The state's collection of more than one million preserved specimens from around the world is one of the largest in Australia and contains specimens of most Australian flowering plants (it is particularly rich in

Victorian species). Flowering plants form the greatest part of the collection, but other plant groups, such as algae, mosses, fungi, lichens and ferns are well represented.

Modern scientists see nature as a complex set of interacting and evolving systems upon which we depend for our quality of life and survival. Conservation has emerged as a critical role of modern botanic gardens worldwide. The increased pace of development and consequent habitat destruction have led to rapid losses of species diversity; many plants around the world are now threatened in a variety of ways, including the introduction of weeds, pollution and global warming.

While taxonomy remains a central research goal at the Herbarium, its activities have expanded to understanding the processes and interrelationships that sustain plant life, through disciplines such as ecology, evolutionary studies and conservation genetics. One of the aims of the Gardens' living plant collections is to cultivate species which are rare, threatened or endangered in the wild. Environmental education programs and living collections themes are becoming increasingly geared towards explaining ecological and evolutionary principles and conservation issues to the public.

Another important aspect of the Gardens' conservation role is the conservation of old ornamental plants that are becoming rare in cultivation. The Gardens provides the space and facilities for experimental research, both within the nursery grounds and the general grounds, as well as providing living specimens for comparison, illustration and description in taxonomic and floristic studies. Some of its living collections also provide information about the horticultural performance of plants that are untrialled in Melbourne conditions, such as the California collection, as well as those currently used for pharmaceutical research, such as the Herb Garden.

In recognition of the need for a worldwide effort towards the advancement of botanical knowledge and conservation, institutions such as botanic gardens and universities now operate as a global network, each ideally specialising in particular fields of interest, such as their regional flora. The Gardens lends

Right: Busbeckea Mitchelli, *a lithogram from Mueller's* Plants Indigenous to the Colony of Victoria: Vol. 1, Thalamiflorae. *(Library, RBGM.)*

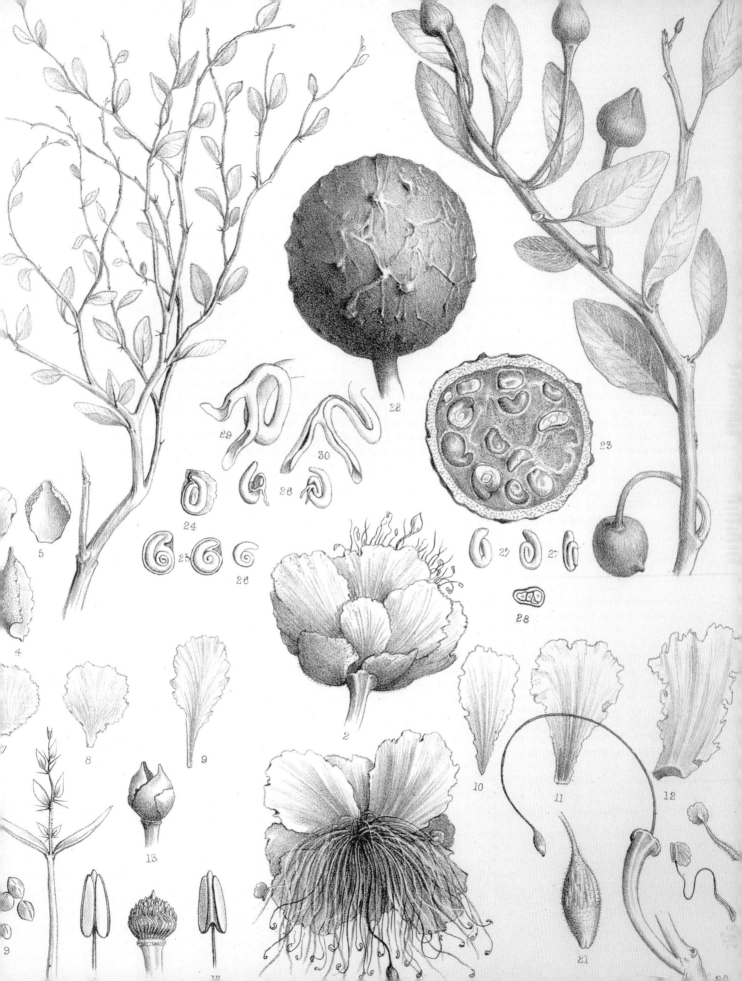

material from its preserved plant collection for research by other scientists (80 000 specimens are currently on loan within Australia), publishes research findings and offers a plant identification service, which is used by government, local councils and members of the general public many of whom are concerned with weed control. For example, a new weed may have appeared in a specific area. If a sample of the plant is sent to the Gardens, they can offer information on what it is and how best to control or eradicate it. Others in the nursery trade and veterinarians also use the service, the latter in cases of animal poisoning.

Technological advances have led to new methods in molecular technology, where it is now common practice to sequence, or read, the code of DNA. As well as comparing the different structures of plants, botanists now sequence and compare DNA codes to help them establish the relationships between plants. Also, comparing DNA from different populations of a rare or endangered species enables botanists to make informed decisions about conserving the maximum amount of genetic variation within that species.

This was demonstrated in 2000, when a tree species discovered in northern New South Wales was found by DNA analysis to have a history going back 65 to 70 million years, when most of Australia was covered in rainforest. Named

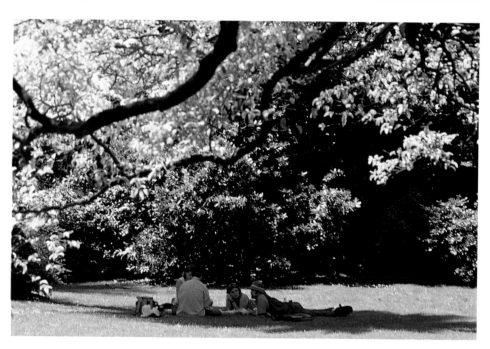

Picnickers on the lawn near C Gate.

Banksia collina R.Br. "Hill Banksia"

(Proteaceae)

Banksia prionophylla

ferd.Mueller.

In the shady moist
vallies of Strzelechys
ranges.

MEL1558512

*A banksia specimen collected by Mueller in April 1853 'in the shady
moist vallies of Strzelechy's ranges'. Originally named* Banksia collina *by
Robert Brown. (Library, RBGM.)*

"Plant specimens from the Herbarium were shipped to England in sealed metal trunks, and Mueller worried incessantly that the ships would sink and his specimens would be lost."

Nightcap Oak, it is the second species of the genus *Eiodothea*, a living fossil from the rainforests that once covered the ancient supercontinent of Gondwana, which consisted of Australia, Africa, South America, Antarctica and New Zealand. The discovery of the first species of *Eiodothea*, *E. zoexylocarpa* revealed another historical connection, which is reflected in its name. More than 150 years ago, Mueller discovered some fossilised fruit in Victoria, which he named *Xylocaryon lockii* 'F. Muell'. Mueller's description and the illustrations of the fruit closely resemble those of the Nightcap Oak (which look very similar to that of a macadamia nut). Hence its name, derived from the Greek word for life, *zoe*, which refers to the living plant, and *xylocaryon* (woody nut), which refers to Mueller's description.

Members of the Herbarium staff still discover and describe new species. Ground-breaking work is carried out in the neglected but ecologically important areas of fungi and algae. Herbarium mycologist, Dr Teresa Lebel, is currently collaborating with fellow scientists in Canberra, Western Australia and the United States to identify truffles that live underground in the forests of southeast Australia. These truffles form the main component of the diet of the potoroo (an Australia marsupial related to the kangaroo and the wallaby). Of the 150-odd species of truffles gathered from southeastern Australia, less than half have been named. By identifying them, Dr Lebel is helping to document biodiversity and add to existing knowledge.

Many of the old ties continue. Formal affiliations with the School of Botany at the University of Melbourne are maintained through the Australian Research Centre for Urban Ecology (ARCUE). A division of the Royal Botanic Gardens Melbourne, ARCUE was created in 1998 with support from the Baker Foundation to help increase understanding of the ecology, restoration and management of urban natural areas throughout Australia and the world. Because of the rapid pace of development around our cities, much of our natural bushland has been lost. ARCUE believes that remnant and revegetated bushlands provide many services, both social and ecological. More than just offering relief from the concrete jungle of urban living, natural bushlands provide soil stabilisation, air purification, flood control, temperature correction, noise reduction and ground-water recharge. Once vegetation is destroyed the plants and animals that are part of the fabric of an ecosystem are also lost. Saving bushland, ARCUE believes, is not so much a matter of resources, knowledge or ability as an issue of human values that focuses on the long-term stewardship of a unique natural landscape. Apart from training undergraduate, honours and postgraduate students, the team at ARCUE also carries out research and publishes its findings. They offer community education and training programs, and policy and management advice to governments.

And the Herbarium staff continues to publish. The last ten years have seen the release of the four-volume *Flora of Victoria* and three volumes of the

Horticultural Flora of South-Eastern Australia. The internationally recognised periodical, *Muelleria*, has been expanded and is being produced twice a year, with a range of topics including taxonomic articles (descriptions of new species and revision of plant groups), ecological reports and bibliographical material. The Herbarium's library, which began with Mueller's personal working library, is now the largest and most comprehensive library of its type in Australia.

The Herbarium's biodiversity research in the Southern Hemsiphere, particularly in Australia, New Zealand and other Pacific countries, has contributed to enormous advances in understanding how our world works. Its services are used by professionals, students and laypeople, while its scientific publications are a critical resource for ecologists, land and water managers, planners and naturalists. In identifying sites of biological significance, new plants, mosses and fungi, the Herbarium's staff help us to better manage and conserve our delicate ecosystem.

Far right: The path to the Herb Garden.

Grey-Headed Flying Foxes (fruit bats), roosting here in two Ridge Myrtle trees (Melaleuca decora). *This colony of flying foxes is a major threat to the Gardens. The many thousands of bats started roosting in Fern Gully then spread to islands in Ornamental Lake and to the beautiful Oak Lawn. The bats strip trees and palms of their foliage and ultimately kill them. In the wild, flying foxes typically roost in an area until the tree canopy is totally destroyed. At the time of going to press, the Gardens was working to find a solution to remove the bats and stop the irreparable damage to plants.*

RESEARCH IN THE HERBARIUM

🌿 Propagating orchids

Southern parts of Australia have a particularly rich terrestrial orchid flora, but these native orchids are among the most threatened plants in Australia. *Caladenia* (Spider Orchid) is the genus that has been worst affected by human activities and introduced plants and animals.

Propagating these orchids so they can be reintroduced into natural sites is one way we may be able to save some of the orchids from extinction. The procedure takes place in the laboratory and involves placing the dust-like seed with mycorrhizal fungi that has been isolated from adult orchid plants. The fungi promotes the germination of the seed and supports the subsequent growth of the orchid. The plants are transferred to nursery pots then prepared for planting out.

In recent years, staff of the Gardens have developed expertise in the micropropagation of Australian terrestrial orchids.

Research into these and other areas helps develop a broad range of strategies to increase the population size of threatened species. 🌿

🌿 New plants for our gardens

Australia has a bountiful natural flora of 22 000 or more native plant species, 90 per cent of which are found nowhere else. This largely untapped resource offers a palette of plants of spectacular beauty which can be used in private gardens or as cut flowers.

The Gardens is helping to bring some of these special plants into general horticultural use by identifying new cut flowers and landscape plants, and establishing new propagating methods for the selection and rapid multiplication of superior forms. For example, in partnership with Plant Growers Australia, the Gardens will release Victoria's Centenary of Federation floral emblem in 2001, a unique red-flowering wattle known as *Acacia leprosa* 'Scarlet Blaze'.

The Gardens is also developing tissue culture methods for the increasingly important cut flower export crops of *Banksia* and other Proteaceae. These techniques will allow plantations of the most desired cultivars to be established quickly. The new cultivars will replace the inferior seedling-grown crops currently in production and protect wild plants from further commercial harvesting.

Australia's rainforest plants are largely ignored by the horticultural industry, but many have leaf textures and colours to complement existing garden plants, and their flowers too can be stunning. A number of species, including some from northeast Queensland, are being trialed in Melbourne, and new propagation techniques developed for their easy assimilation into the horticulture. 🌿

Conservation projects

Conservation genetics and ecology combine at the Gardens to ensure that our threatened species are managed in ways that shift the balance in favour of their long-term sustainability.

Borya mirabilis is a diminutive lily found only in the Grampians National Park in western Victoria. The Gardens has an ex-situ collection which is used to study the genetic diversity, reproduction and nutritional requirements of the species. By propagating from these cultivated plants, the number of plants available for replanting in the Grampians is expanding.

Grevillea infecunda, found only near Anglesea in Victoria, no longer produces seed. Genetic studies at the Gardens have shown that the flowers are male and sterile. As the species is no longer capable of setting seed, work at the Gardens focuses on encouraging the few remaining populations to reproduce via root suckers.

The variety of Victoria's native grasses has severely diminished as its grasslands have been used for agriculture. Staff at the Gardens are studying Victorian species of the genus *Agrostis* for their salt tolerance, in the hope that they can be used for rehabilitating agricultural areas affected by increasing salinity. If native grasses can be used instead of the introduced species currently in the areas, they will provide habitat for native flora and fauna and reduce the impact of introduced weeds. Other grassland species such as the Sunshine Diuris, *Diuris fragrantissima*, are being reintroduced after the genetic diversity of the ex-situ material has provided a basis for a breeding program to ensure that the seedlings produced are as genetically diverse as possible.

Conservation projects at the Gardens also extend beyond Australia's shores. The sacred Toromiro, *Sophora toromiro*, is no longer growing wild in its native habitat on Easter Island and survives only in collections in botanic gardens. The Gardens is part of a collaborative worldwide effort to reintroduce the plant to its native habitat.

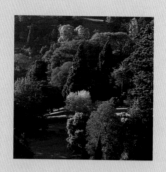

Present and Future

DIRECTIONS

TODAY'S ROYAL BOTANIC GARDENS Melbourne has responded to the demands and expectations of a modern urban community, yet retains its nineteenth-century links. Charles La Trobe saw it as a place for retreat; Ferdinand von Mueller felt it should be a place for scientific pursuit and education; while William Guilfoyle claimed it as a park for the people. In fact the Gardens fulfils all these functions. The landscape architects, botanists, engineers, gardeners, horticulturists and administrators who plan, design and cultivate this magnificent urban icon strive not only to acknowledge its history and remain true to its Picturesque design, but also to explore and create new areas, both aesthetically and scientifically. And, of course, they strive to keep the Gardens in touch with La Trobe's spirit, ensuring that they still provide a calm, luxuriant space.

Although most visitors see the Gardens as a haven, an inspiring landscape in which to take a book, enjoy the scenery and relax, the beautiful landscape is more than just a place for public leisure. Its primary aim as a botanic garden is to increase knowledge and enjoyment of plants, as well as awareness of their essential role in our ecosystem.

Probably one of the largest problems facing the Gardens today is finding a way of maintaining Guilfoyle's ornamental landscaping framework against the passage of time. But change, when it comes to something as constantly shifting as nature, is inevitable. While Guilfoyle's design is integral to the Gardens' history, it is neither possible nor desirable to simply try to maintain it. The growth, death and renewal of plantings means the landscape can never be the same from year to year. As the trees, plants and shrubs have matured, the scale of the Gardens has altered and, with that, its appearance. Many of Guilfoyle's wide vistas have disappeared under the shade of canopies of ageing trees – one-third of the trees planted during his tenure still survive, while two-thirds of the plants there today were planted since his retirement in 1909. The master landscaper's garden beds have been modified and his beloved floral displays have reduced in number. However, visitors will still find plantings that hark back to Guilfoyle's naturalistic or rustic style, such as the Fern Gully, as well as his more

"As the trees, plants and shrubs have matured, the scale of the Gardens has altered. Many of Guilfoyle's wide vistas have disappeared under the shade of canopies of ageing trees."

formal, highly stylised Gardenesque arrangements of ornamental borders, smooth lawns and horticultural specimen trees.

Conserving the Gardens' changing landscape means respecting the essential aspect of Guilfoyle's landscape design and character, while creating opportunities for new collections and developments. Consequently, many garden beds now hold a living reference 'library' of plants, where an enormous collection of plants from around Australia and the world are displayed in an ornamental landscape setting. Rather than the distinct taxonomic groupings that characterised Guilfoyle's era, the living collections are arranged thematically in geographic, ecological, conservation and horticultural groups, which reflect the wider roles botanic gardens must play nowadays.

The Gardens' major plant collections include a vast array of cacti, aloes and agaves, which show how these succulents from desert regions can survive and even flourish in Melbourne's sometimes frosty winters. A wide range of

eucalypts and seasonal native wildflowers fill the Australian Eucalypt Lawn. In autumn, the great oaks are a mass of colour, while the Perennial Border is a tribute to the planting style popularised at the turn of the twentieth century in England by Gertrude Jekyll, who was influenced by the impressionist painters' use of colour.

The visually arresting grey-and-white foliage of the Grey Garden's plants surround Guilfoyle's tribute to Charles La Trobe, the Temple of the Winds. The Herb Garden displays a variety of culinary plants in a traditional Elizabethan setting. The superb camellia collection was given an award for 'Camellia Garden of Excellence' in 2000 by the International Camellia Society. It demonstrates a full range of cultivars developed by early Australian camellia breeders, providing botanists with valuable reference material, and helping to conserve rare and endangered *Camellia taxa*; they are a special treat in the winter months, and the varieties on display exceed 300. Begun during Guilfoyle's term and considerably increased during Jessep's directorship, the camellia collection became the Australian National Reference Collection of the Australian Camellia Research Society in 1996.

The Australian Rainforest Walk, the Water Conservation Garden and the Species Rose Collection are among the more recently developed collections. Located near B Gate where a rose garden was planted many years before, the rose collection was designed by the Gardens' landscape architect, Andrew Laidlaw, and Ian Huxley and Matt Howard. Although loosely based on the parterre style – a garden on flat ground, in which the pattern of the garden is usually as important as the plants – the new beds' shapes are not conventional parterre shapes, but dissect the large triangle into smaller, more usable spaces. Sculptor David Wong was commissioned in 1999 to create the climbing frames that line the paths. Planted with climbing roses, the structures provide vertical interest in winter and colour in the warmer months. The Species Rose Collection contains many roses that are displayed in beds grouped in geographical zones (Europe, America, Middle East and Asia). The bulk of the beds are planted with species roses and the two internal paths hold old 'garden

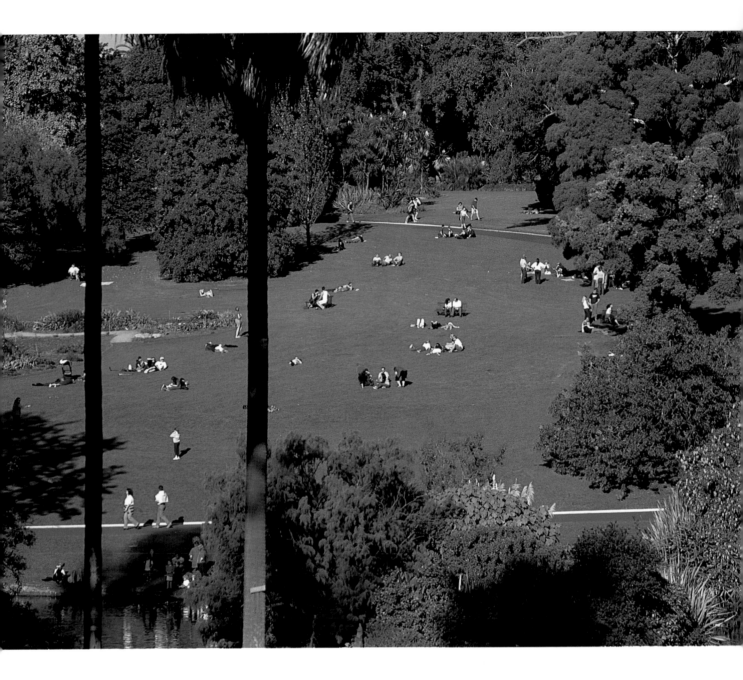

The picnickers on Central Lawn are out in force to take advantage of one of the last sunny weekends in autumn.

roses', which were bred before the development of the modern Hybrid Tea. Three smaller triangular-shaped beds feature *Rosa* 'Victoria Gold', an Australian-raised *floribunda* chosen by the Rose Society of Victoria to commemorate its centenary in 1999.

Perhaps one of the most informative of the new collections is the Water Conservation Garden. Domestic gardens consume about 30 per cent of Melbourne's domestic water supply; this, combined with the prolonged dry spells of Victoria's summers, highlights the need for gardens that demonstrate water-saving principles. The planting approach at the Botanic Gardens has been to use hot-coloured groundcover and shrub material, with an emphasis on large drifts of perennials interspersed with vertical elements and succulent plants, such as agaves and yuccas. The central bed's planting display changes every four to five years. Most of the plants used are readily available to the public and range from annual to perennial shrubs and trees with long flowering periods, a striking form or unusual textural features. Domestic-style sprinklers demonstrate what can be achieved in the home garden. The Water Conservation Garden is watered less frequently than other collections, so as to produce figures comparing water use to that in traditional, less water-wise plantings.

Two interesting designs are planned for the future. The Gardens has grown Chinese trees and plants since the beginning, with some splendid old specimen trees, such as the rare *Taiwania formosana* on the Western Lawn, the Funeral Cypress (*Cupressus funebris*) near the tea rooms and two elderly lawn specimens of *Keteleeria fortunei*. They are now creating a new Southern Chinese Collection on the Gardens' north side (near H Gate). Rather than simply emulate a traditional Chinese garden, the designers of the present garden have borrowed some elements, such as the zigzagged curving path through the borders. In Chinese superstition, it is said that evil spirits can only travel in straight lines and will become lost on a zigzagged path. Some of the design features, such as the still water views that

Inset: Dasylirion *sp.*

reflect the surrounding landscape, will always remain — water being seen as the yin or female element, which gives life to the scenery.

Many of the plants used in the new collection are highly ornamental in form, foliage or fruit. Four maples *(Acer pentaphyllum)*, which are rare in the wild as well as in cultivation, have been planted along the path to eventually form an avenue. A young birch tree (*Betula utilis*) with bronze peeling bark was collected as seed from Na Pa Hai Mountain in Yunnan, China. The Ginkgo or Maidenhair Tree (*Ginkgo biloba*) in the collection is planted in Chinese streets and parks and ancient specimens are found in temple gardens. This once-rare tree is now grown commercially for its seed, as well as for a compound found in the leaves that is used in traditional Chinese medicine. A medicine produced from its foliage is used worldwide to treat vascular disease and heart problems. The seeds are used in western medicine as an astringent and to treat asthma, and in Chinese culture as a food.

Two young *Magnolia denudata* — commonly called *yulan* or lily tree — produce exquisite flowers that have appeared in Chinese art for centuries. And, since Southern China is home to a majority of the world's camellia species, eight have been planted in the collection, including the tea-oil camellia, *C. oleifera*. The voluptuous peony roses such as *Paeonia suffruticosa*, *P. delavayii*, *P. lutea* and *P. rockii*, which have long been cultivated in China, are represented in the collection.

The new Ian Potter Foundation Children's Garden is being designed to delight generations to come. A garden built for children, it will be a magical spot that kids can call their own. Pre-fabricated play equipment will be banned — the sense of adventure is to be found in the landscape. Children will be able to dig, build, create, grow, hide and explore. A safe and dynamic landscape will feature plants, water, structures and pathways that reflect the changing season and will help to build youngsters' awareness and affinity with the natural world through play, exploration and discovery. Young visitors will be able to explore the world of plants from below and above the ground. Arbours, tunnels, sculptures, topiary, houses and mazes might all be constructed from plants, while fountains, fog

mists, cascades, rock and marsh pools will surely entice and provide much pleasure. Located near O Gate, close to the Visitor Centre and Observatory Cafe, the Children's Garden features a sculpture of the Australian classic, the *Magic Pudding* by Louis Laumen. It will offer a spot for children and their families to explore, enjoy and learn.

Perhaps the project that best captures many of the Gardens' objectives is at Long Island at the northwestern reach of Ornamental Lake, where the aboriculture crew and the Conservation Volunteers' Australia Green Corps team are recreating the indigenous vegetation that existed there before white people came. Wetlands, swamp paperbark and grassy woodland will once again dominate the island, in an attempt to restore an ecosystem that is now terribly threatened. Grassy woodlands once provided food and home for animals such as kangaroos, lizards, birds and butterflies. Flowing grasses and swaying reeds, which dominate the water's edge, offered food, shelter and safe breeding sites for birds, reptiles and fish. Some of these animals may return to Long Island once the vegetation regenerates.

Future plans for the Gardens also look to renovating the rockeries and the reservoir. The cone-shaped reservoir built by Guilfoyle in 1876 to resemble a volcano has been out of use for many years. There are now plans to restore it according to Guilfoyle's original concept and redevelop it as a central component of a unified series of rockeries along the southeast border. The reservoir will be a landscape feature as dramatic and beautiful as its original designer intended.

Not many of those enchanting nineteenth-century rustic buildings and structures still exist at the Gardens. In the 1950s and 1960s summer houses, lodges, rest houses and bridges were demolished. But the 1990s saw a wave of conservation and redevelopment of a number of historic buildings, such as the old Observatory site. The new Observatory Gate opens to modern indoor and outdoor cafes, a shop and the Visitor's Centre, and yet its landscape designs integrate well with the Gardens' existing character and respects the history that lies within its space.

Overleaf: Central Lake.

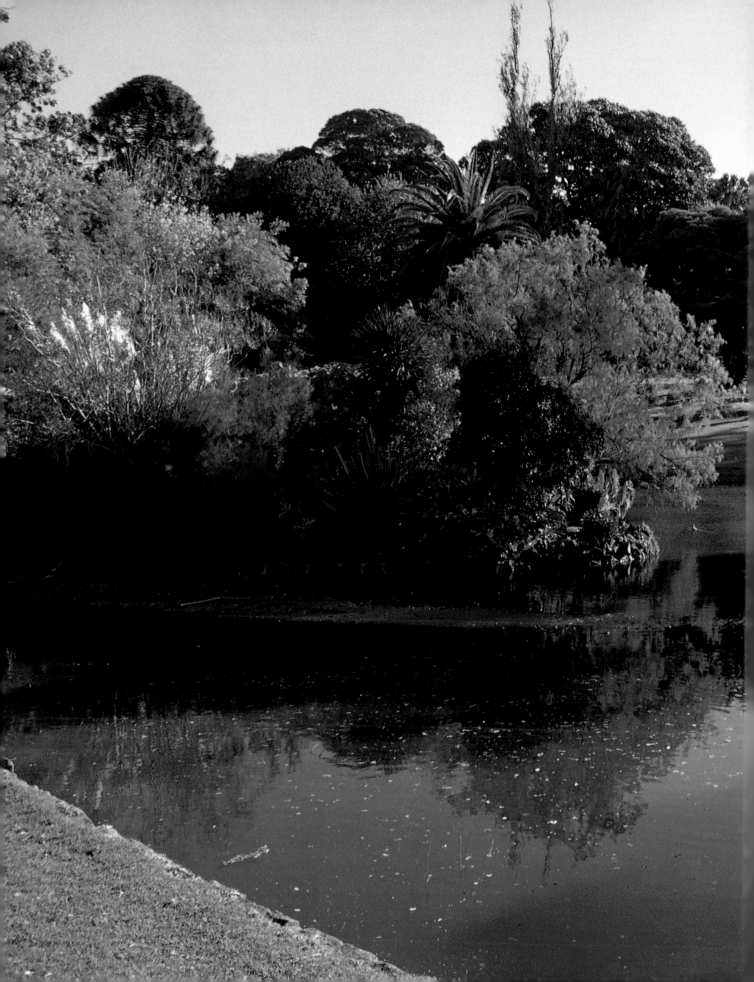

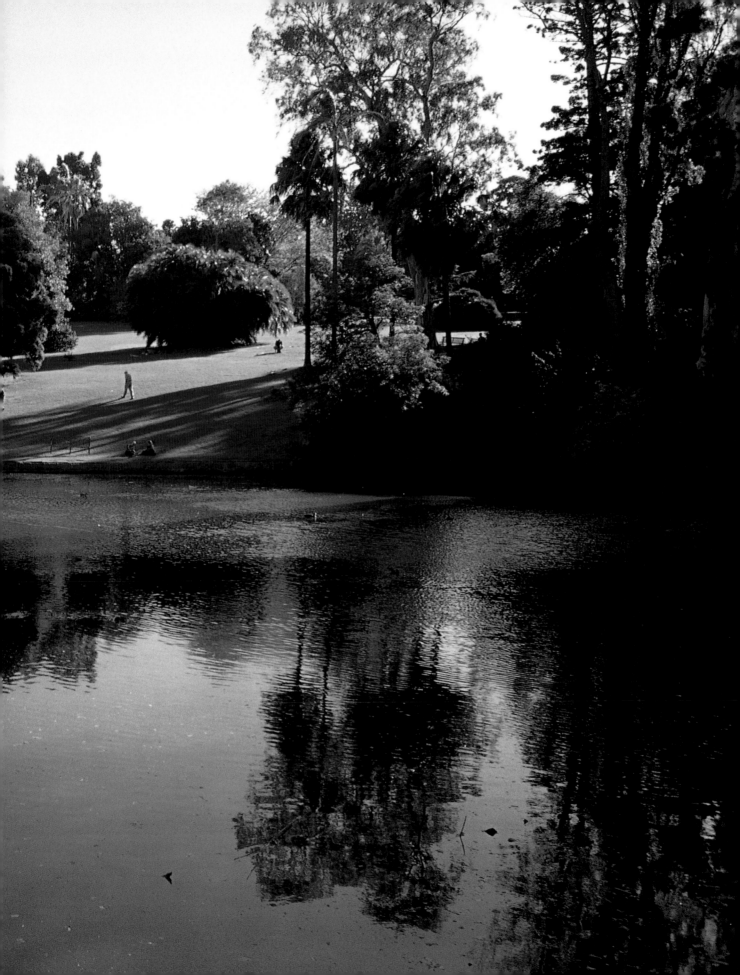

Today, more than ever, Melbourne's Botanic Gardens play an important part in the life of local residents and tourists. A vibrant cultural life has been developed at the Gardens, which now acts as a setting for tourism, dining, theatre, exhibitions and special events. Thousands of people visit the Gardens each year, from all over the world, to take part in these cultural experiences. Observatory Gate's new facilities for performing and visual arts, exhibitions and educational programs also assist the Gardens' botanic duties, by fostering community support, encouraging visitors and ensuring its financial viability.

New technology has played a part in all of the changes, but probably mostly in science and education. Kindergarten children through to adult learning groups come regularly to look, listen and learn. And, through multimedia outlets, the Gardens is likely to attract a growing education-based market.

The Gardens has been blessed with an excellent site, a reasonably temperate climate and the vision of three gifted and talented forefathers. It has comprised a unique part of Melbourne's living heritage. While it strives to retain its nineteenth-century beginnings, it must also evolve with the times. Conservation is a major theme for the Gardens, but it is also seen as forward-looking in science and landscape design. It is a difficult balancing act.

The Royal Botanic Gardens Melbourne has travelled far since its inception. From a billabong surrounded by rushes, trees and scrub, it is now recognised around the world for its historical significance, cutting-edge research and, of course, for its beauty. To Melburnians, however, the Gardens is as much and as familiar a part of the urban landscape as the MCG or Flinders Street Station. Melbourne is blessed with many wonderful parks and gardens, but none has played such an integral part in the city's development. The Royal Botanic Gardens Melbourne has been around for almost as long as the city itself and will continue to grow, as the city does.

Overleaf: A Liquidambar (Liquidambar orientalis), *at left, and a Yellow Stringybark* (Eucalyptus muelleriana) *on Eastern Lawn.*

ACKNOWLEDGEMENTS

I would like to acknowledge the help of all the staff at the Royal Botanic Gardens Melbourne, but especially Jill Thurlow, Helen Cohn, Richard Barley, Philip Moors, Roger Spencer, Susan Gregory, Jim Ross, Damien Adams, Kiah Martin, Sabine Glismann-Gough, David Cash, Stephen Paterson, Laurie Zarafa, Maggie McNamara, Peter Symes and Andrew Laidlaw.

SOURCES

The following books, articles and manuscripts were used in researching this book:

Aiken. R. (1996), 'Picturesque but Instructive: William Guilfoyle's First Decade at the Melbourne Botanic Gardens', *Australian Garden History*, vol.7, no.5, pp.6-18.

Archer, B. and S. Maroske (1996), 'Sarah Theresa Brooks – Plant Collector for Ferdinand Mueller', *The Victorian Naturalist*, vol.113, no. 4, pp.188-94.

Aston, H. (1996), 'Dr James Hamlyn Willis AM, 28 January 1910– 10 November 1995', *Muelleria*, vol. 9, pp.1-4.

Baracchi, P. (1898), 'Section A: Astronomy, Mathematics and Physics, Presidential Address', *Report of the Seventh Meeting of the Australasian Association for the Advancement of Science, 1898*, pp.157-75.

Bate, W. (1996), 'Perceptions of Melbourne's "Pride and Glory"', *Victorian Historical Journal*, vol.67, no.1, pp.4-16.

Beckwith, S. C. (1997) *Royal Botanic Gardens, Melbourne, master plan*, South Yarra, Victoria.

Broome, R. (1994), *The Victorians: Arriving*, Melbourne.

Cannon, M. (ed.) (1982), *The Aborigines of Port Phillip 1835–1839*, Melbourne.

Clarke, F. (1924), *In the Botanic Gardens: Their History, Art and Design, with Stories of the Trees*. Melbourne. (Later editions 1938 and 1944.)

Cohn, H. M. and S. Maroske (1996), 'Relief from Duties of Minor Importance: The Removal of Baron von Mueller from the Directorship of the Melbourne Botanic Garden', *Victorian Historical Journal*, vol. 67, pp.103-27.

Davison, G. (ed.) (1998), *The Oxford Companion to Australian History*, Melbourne, pp.15, 701.

Eidelson, M. (1997), *The Melbourne Dreaming: A Guide to the Aboriginal Places in Melbourne*, Canberra.

Ellery, R. (1870), *Progress of Astronomy*, Lecture, Duke of Edinburgh Theatre, 25 July 1870.

Gregory, S. (1999), *Melbourne Observatory*, RBGM (unpublished).

Gross, A. (1956), *Charles Joseph La Trobe*, Melbourne.

Guilfoyle, W. R. (1877) *Annual Report on the Melbourne Botanic Gardens, Government House Grounds and Domain*, Melbourne.

Guilfoyle, W. R. (1883), *Catalogue of Plants Under Cultivation in the Melbourne Botanic Gardens, alphabetically arranged*. Melbourne.

Henty, C. (1988), *For the People's Pleasure: Australia's Botanic Gardens*. Richmond, Victoria.

Hume, R. et al. (1998), *Regardfully Yours: Selected Correspondence of Ferdinand von Mueller*, Bern.

Jellie, P. (1996), *Chronological Landscape History of The Royal Botanic Gardens Melbourne*, South Yarra, Victoria.

Jessep, D. (1994), interviewed by Darren Watson for the Oral History Project for the Royal Botanic Gardens Melbourne. (RBGM archives.)

Kynaston, E. (1981), *A Man on Edge*, Ringwood, Victoria.

La Trobe to Town Clerk of Melbourne, December 1845, (RBGM archives, MSS 439D).

Lamb, R. (1996), 'Under Pressure: The Evolution of the Water Supply System of the Royal Botanic Gardens', *Victorian Historical Journal*, vol. 67, pp.66-82.

Law-Smith, J. (1984), *The Royal Botanic Gardens Melbourne*. Melbourne.

Mueller, F. (1857) *Report on the Botanic Garden, Melbourne*, Melbourne.

Newsletter from Australasia, no.28, December 1856.

Official File RS 4266, Department of Crown Lands and Survey, Melbourne.

Pescott, R. T. M. (1974), *W. R. Guilfoyle 1840–1912: The Master of Landscaping*, Melbourne.

Pescott, R. T. M. (1982), *The Royal Botanic Gardens Melbourne: A History from 1845 to 1970*, Melbourne.

Petition to the Governor and Commander in Chief of New South Wales, 26 November 1884, (RGBM archives, MSS 439D).

Pitcher, F. (1910), 'Victorian Vegetation in the Melbourne Botanic Gardens', *Victorian Naturalist*, vol. 26 pp.164-79.

Presland, G. (1985), *The Land of the Kulin: Discovering the Lost Landscape and the First People of Port Phillip*, Melbourne.

Rush, J. (1994), interviewed by Darren Watson for the Oral History Project for the Royal Botanic Gardens Melbourne. (RBGM archives.)

Sandford, K. (1994), interviewed by Darren Watson for the Oral History Project for the Royal Botanic Gardens Melbourne. (RBGM archives.)

Shaw, A. G. L. (ed.) (1989), *Gipps–La Trobe Correspondence 1839–1846*, Melbourne.

Symes, P. (2000), Implementation of New Irrigation Management Strategies at the Royal Botanic Gardens Melbourne, RBGM (unpublished).

Taylor, A. (1996), 'Baron von Mueller in the Field Naturalists' Tradition', *Victorian Naturalist*, vol. 113, pp.131-9.

Victorian Agricultural and Horticultural Gazette, vol. 1, 1857-58.

Victorian Parliamentary Papers (1854), *Returns of the Department of the Public Service, 5 May 1854*. Melbourne.

NOTES

p.16 'protection and civilisation of native tribes' cited in Shaw (1989), p.xiii.

pp.17-19 The piece on the Old Melbourne Observatory was derived from notes written for RBGM guides by Susan Gregory, and conversations with her.

p.18 'Never was a city' cited in Gregory (1999), p.38.

p.18 'There is no such thing' cited in Ellery (1870).

p.19 'our heritage' cited in Baracchi (1898).

p.20 'It is of vital importance' cited in *Petition*, 26 November 1844.

p.20 'to set aside as places' cited in *Petition*, 26 November 1844.

p.21 'a veritable Garden of Eden' cited in Pescott (1982), p.10.

p.23 'If you will come' cited in Pescott (1982), p.10.

p.23 'Government agent for the civilisation of the Aborigines' cited in Cannon (1982), p.502.

p.23 'look after the moral and religious training of aborigines' cited in Pescott (1982), p.10.

p.26 'of acknowledged activity and talent' Official File RS 4266, Department of Crown Lands and Survey, Melbourne.

p.30 'The garden is finely situation' cited in Bate (1996), p.5.

p.31 'The trees and shrubs' cited in Pescott (1982), p.23.

pp.34-5 Jessep (1994).

p.39 'There is an honest-looking German here' cited in Kyanston (1981), p.24.

p.39 'In accordance with' cited in Pescott (1982), p.42.

p.41 'with a view to rendering' cited in Jellie (1996), p.5.

p.42 '[It] must be mainly scientific' cited in Pescott (1982), p.42.

p.42 'natural system' and 'to demonstrate' cited in Pescott (1982), p.43.

p.48 'A Pinetum will be reared' cited in Pescott (1982), p.43.

p.48 'the interchange' cited in Jellie (1996), p.11.

p.50 'very injurious' cited in Cohn and Maroske (1996), p.10.

p.54 'urge inland and northern' cited in Cohn and Maroske (1996), p.190.

p.55 'Coming back to civilisation' cited in Cohn and Maroske (1996), p.193.

p.57 'a man of large experience' and 'the Government avail itself' cited in Pescott (1982), p.96.

p.62 'Nothing can excel' cited in Jellie (1996), p.12.

p.63 'state of confusion in which I find this Garden' cited in Pescott (1974), p.80.

p.65 'to cut down a number' cited in Pescott (1974), p.80.

p.65 'One of the great essentials in landscape gardening' cited in Pescott (1974), p.81.

p.66 'landscape beauty seems' cited in Pescott (1974), p.81.

p.66 'boy assisting the seedsman' cited in Pescott (1982), p.157.

p.66 'benefit of the Baron' cited in Taylor (1996), p.135.

p.67 'affording a bright and elastic turf' cited in Jellie (1996), p.27.

p.67 'Remodelling a Garden' cited in Pescott (1974), p.88.

p.71 'where it is necessary' cited in Pescott (1982), p.105.

p.71 'all doing well', 'In no other Colony' and 'generally considered unfavourable for this sort of work' cited in Pescott (1982), p.105.

p.71 'a judicious mixture' and 'I also have in view' cited in Pescott (1982), p.107.

p.72 'introduce the warmth' and 'to take its proper place' cited in Jellie (1996), p.27.

p.82 'splendid musical treat' *Argus*, 1 March 1853, p.5.

p.83 'hurricane' *Argus*, 1 March 1853, p.5.

p.83 'the rare and beautiful' *Argus*, 9 March 1853, p.4.

p.83 'favourite place of promenade' cited in Pescott (1982), p.30.

p.86 'in defiance of the law, shoot in the police paddock' *Argus*, 2 April 1853, p.5.

p.86 'The Melbourne Botanic Gardens' *Newsletter of Australasia*, no.28.

p.87 'The Show of flowers' *Victorian Agricultural and Horticultural Gazette*, p.9.

p.87 'numerously and fashionably attended' cited in Pescott (1982), p.40.

p.89 'these Gardens were established' cited in Pescott (1982), p.127.

p.90 'Of all the entertainments' cited in Pescott (1982), p.127.

p.91 Rush (1994).

p.94 'under no condition' cited in Pescott (1982), p.180.

p.101 'monotonous' cited in Jellie (1996), p.16.

p.101 'warmth of colouring' and 'vary the monotony of the Pampas Grass' cited in Pescott (1982), p.108.

p.103 'one grand fountain in the centre of the gardens' cited in Pescott (1982), p.122.

p.103 'It cannot be denied' cited in Pescott (1982), p.65.

p.106 Sandford (1994).

p.107 'Tall Danubian Reeds' cited in Jellie (1996), p.8.

p.108 'Both in the Domain' and 'During the drought' cited in Lamb (1996), p.71.

p.115 'at the bridge crossing' cited in Pescott (1982), p.120.

p.116 'when the scheme' cited in Lamb (1996), p.73.

p.122 'When a botanist first enters' cited in Gregory (1999), p.38.

p.122 'a man of a thousand' cited in Gross (1956), p.7.

p.127 'must be mainly scientific' cited in Pescott (1982), p.42.

pp.129, 131, 133 The piece about Jim Willis originated from his obituary, Aston (1996).

pp.142-3 'Research in the Herbarium' was written by staff of the RBGM. The pieces on propagating orchids and new plants are by Rob Cross, Horticultural Botanist.

INDEX

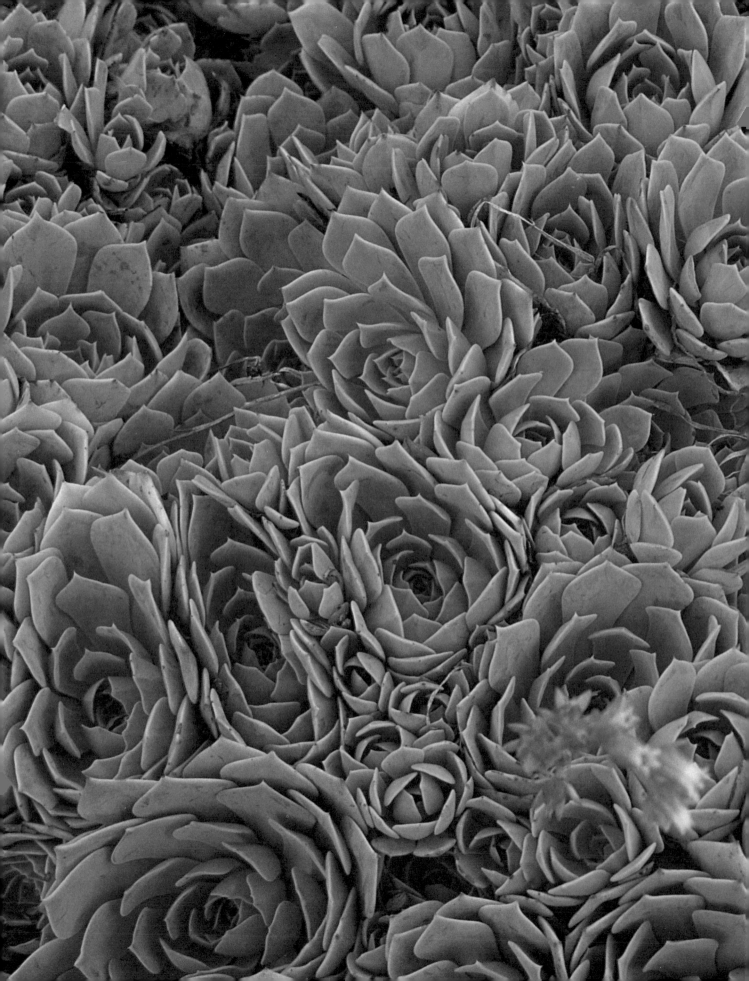